ABANDONED OKLAHOMA

VANISHING HISTORY OF THE SOONER STATE

ABANDONED ATLAS FOUNDATION

AMERICA
THROUGH TIME®
ADDING COLOR TO AMERICAN HISTORY

America Through Time is an imprint of Fonthill Media LLC
www.through-time.com
office@through-time.com

Published by Arcadia Publishing by arrangement with Fonthill Media LLC
For all general information, please contact Arcadia Publishing:
Telephone: 843-853-2070
Fax: 843-853-0044
E-mail: sales@arcadiapublishing.com
For customer service and orders:
Toll-Free 1-888-313-2665

www.arcadiapublishing.com

First published 2021

Copyright © Abandoned Atlas Foundation 2021

ISBN 978-1-63499-301-2

All rights reserved. No part of this publication may be reproduced, stored in a retrieval
system or transmitted in any form or by any means, electronic, mechanical, photocopying,
recording or otherwise, without prior permission in writing from Fonthill Media LLC

Typeset in Trade Gothic 10pt on 15pt
Printed and bound in England

CONTENTS

DEDICATIONS

MICHAEL SCHWARZ

I want to thank everyone who helped create this book and keep AOK and AAR running, except for that one guy at my friend's tenth birthday party who told me to "only have one slice of pizza" so that they could have lots of leftovers. There was enough for everyone to have three slices and you know it, jerk! It feels good to finally get that off my chest. Thanks, everyone!

EMILY COWAN

I want to thank Michael Schwarz for giving me a chance and bringing me onto the team. He taught me and educated me every time I asked questions and was interested in learning. He paved the way for me to finally get Abandoned Kansas up and running. He has opened many opportunities for me to grow my connections and skillset. Thanks for everything.

JENNIFER BURTON

The opportunities I have had over the years to explore the places I have been wouldn't have been possible without having like-minded teammates to experience these locations with. I would like to thank all the AbandonedOK team members, Cody Cooper, Michael Schwarz, Emily Cowan, David Linde, Billy Dixon, and Johnny Fletcher for their

continued dedication to historic preservation, and a special thank you to Leslie Flaming, who is always there with me for all the amazing adventures. I would like to thank my parents, Ed and Sharon Smith, for always being understanding and encouraging of my strange curiosity, and my husband and our children, who also appreciate our mission at AOK. I am very grateful for all the support I have received from countless family and friends alike, and I hope to continue this journey for years to come.

Johnny Fletcher

I would like to acknowledge and thank the following: God, who has always been there along the way and saved me from peril a number of times; Bianca Fletcher, my beautiful daughter who never ceases to amaze me, and has gone on quite a few adventures with me; Tabitha Rayl, my love and sidekick who is patient with me always and has recently taken an interest in exploring; Billy and Megan Dixon, thank you for being my closest friends, the universe matched us up perfectly with our love of horror and music and I can't express my thanks for how loving and giving both of you are to my family; David Linde, if it wasn't for you, my friend, none of this would have been possible; Justin Tyler Moore, you are not forgotten, thank you for your visions; Chardonnay Brown, thanks for mentioning that exploring website to me, that was the spark that started the fire; Cody Cooper, thank you for being there and being a visionary in your own right; Jennifer Burton and Leslie Flaming, the dynamic duo (in my mind), thank you for always being around and following me on our own attempt to keep things alive; Michael Schwarz, forgiveness makes friendships—thanks for being a driving force that is keeping everything going; Emily Cowan, the new kid (as of this writing we haven't met), thank you for being smart and doing fabulous writing on our articles and posts as another young urban exploring visionary; Sean Tompkins, my best bud since childhood, we've gone on lots of crazy adventures throughout life—my friend in horror, my friend in music, my friend in life—thank you for always being there.

Billy Dixon

Thank you for reading this right now. Without an audience this book would have never come to be. Writing a thank you page has always made me frantic, because I am certain I would leave at least one person out. If you have helped me, supported me, looked at my photos, or let me ride shotgun, you know who you are. Write your name here:

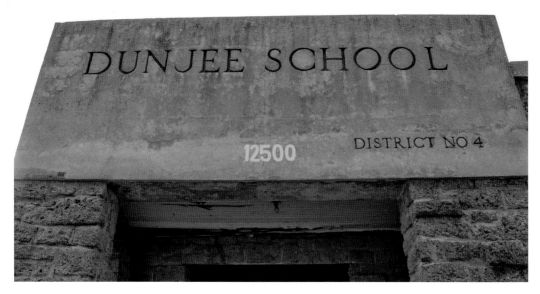

District No. 4, Dunjee School, original facade, 1947. [*Michael Schwarz, 2011*]

1

THE PRIDE OF OUR BEGINNINGS

Michael Schwarz

Growing up, I was never interested in history class, but when I stepped inside an abandoned building for the first time, there was something about the stagnant smell or the sight of Mother Nature finding a new home inside that grabbed me. To its root, I have always believed history answers the question, "Why?" I love researching that question—where these places come from, why they are left, and what's next.

From a weekend hobby to what is now a way of life, I've been photographing and documenting these forgotten structures for almost eight years now, and there are two questions people always ask me: "How do you find these places?" and "Why do you do this?" The answer to the first question is easy. Sometimes they can be found in the middle of a town and some are hidden away in the trees off of a dirt road. Try taking the backroads, look around on Google Maps, and just get out and explore. There are so many wonderful things to see in this world and you're not going to find anything if you're not looking. However, my answer to the second question has changed many times over my life and it's all centered around one building in Spencer, Oklahoma: Dunjee Academy.

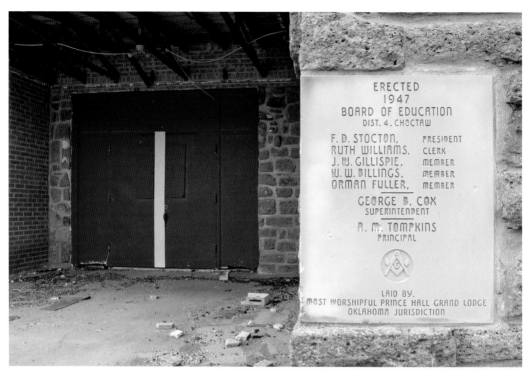

Outside auditorium, Dunjee School Cornerstone. [*Michael Schwarz, 2011*]

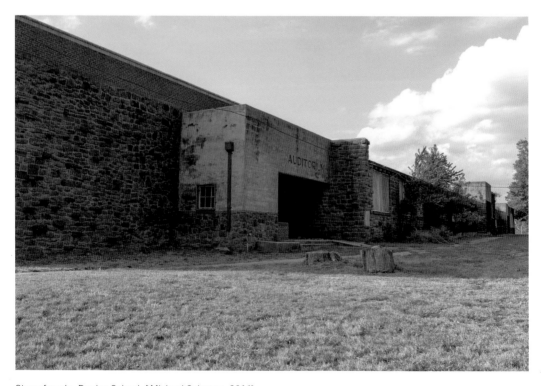

Stone facade, Dunjee School. [*Michael Schwarz, 2011*]

FIRST VISIT: 2011

From the outside, Dunjee seemed like any other small-town school, with large classroom windows, a stone facade, and attached auditorium/cafeteria, but when I stepped inside for the first time, it was something I had never experienced. Most of the abandoned buildings I had been to up to this point were gutted, vandalized, or used by the owner to store their broken printer parts and other useless junk. Not Dunjee. This school was a true textbook definition of a time capsule. There were books on the shelf, assignments on the board, and even a teacher's desk that had only half of an assignment graded. Walking down the hall, I kept expecting the bell to ring and for students to come out of the classrooms laughing and getting ready to go home for the day. Instead, all I could hear was the floor cracking and creaking with every step I took. From the class syllabi lying on the floor to the literature book on the dust blanketed desk, Dunjee was a "one-of-a-kind" explore, offering something unique in every room. I couldn't stop taking pictures.

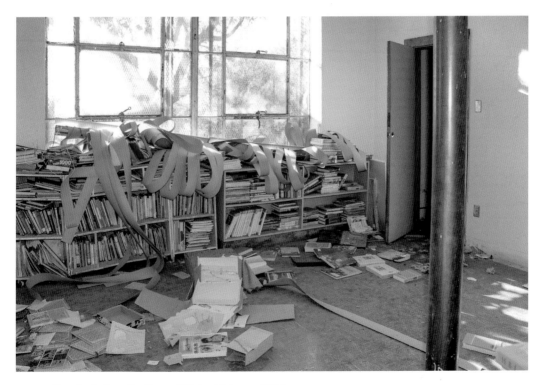

More books from the library. [*Michael Schwarz, 2011*]

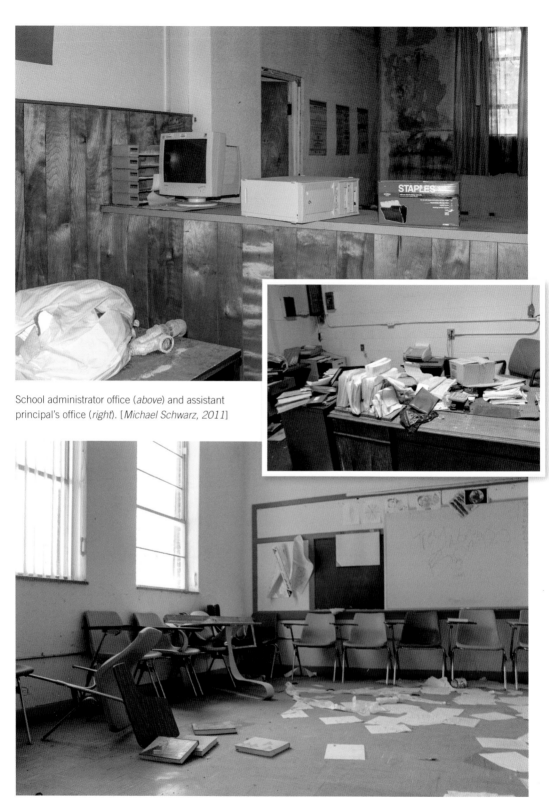

School administrator office (*above*) and assistant principal's office (*right*). [*Michael Schwarz, 2011*]

English classroom. Books, desks, and papers scattered everywhere. [*Michael Schwarz, 2011*]

9th grade Oklahoma history homework. Social Studies classroom. [*Michael Schwarz, 2011*]

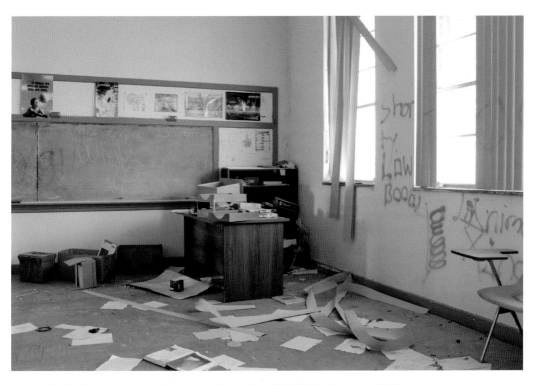

English Classroom, teacher's desk, small sign of graffiti. [*Michael Schwarz, 2011*]

As a relatively new urban explorer, I quickly learned that if you see a refrigerator, leave it closed. That is unless you are willing to take on the festering old food odor. It is never a pleasant smell.

Given that this hidden gem was only thirty minutes from my house, I kept finding myself coming back again and again. Looking through papers on the ground and photos on the wall, I was trying to find out exactly why this community school closed. It was as if everyone just got up and left in a hurry. Based on the dates written on the board, I had a pretty good idea of when it closed, but there was no evidence as to why. That's when I finally decided to turn to a good friend of mine, Bing. (Just kidding, obviously it was Google.) Let's start from the beginning of where Dunjee's name originated.

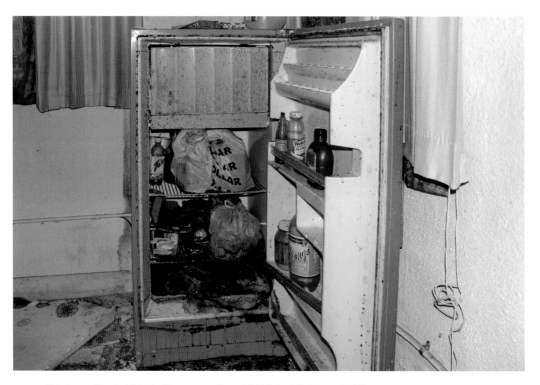

This is exactly what it looks like; anyone hungry? [*Michael Schwarz, 2011*]

OPPOSITE PAGE:

Above: Textbooks from world geography, pre-algebra, biology, and more. [*Michael Schwarz, 2011*]

Inset: Lockers in the hallway. [*Michael Schwarz, 2011*]

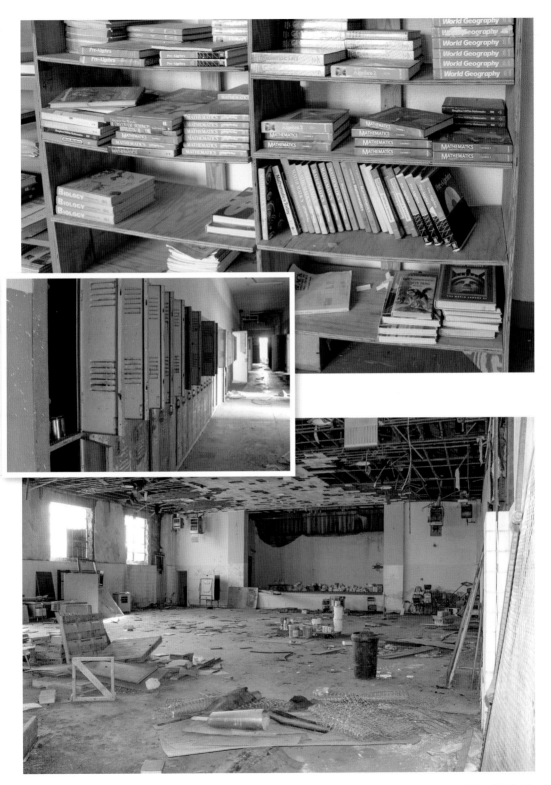

Auditorium/cafeteria. Lots of paint cans were piled around. One was tipped over and a big blob had dried right into the floor. [*Michael Schwarz, 2011*]

ROSCOE DUNJEE AND THE BLACK DISPATCH: HISTORY

As an editor of Oklahoma City's only black newspaper, Roscoe Dunjee led the way in the struggle for civil rights in Oklahoma and in the black community of the Oklahoma City region. According to the Oklahoma Historical Society, it was on November 5, 1914, that Roscoe Dunjee printed the first issue of the *Black Dispatch*. The new publication endeavored "to interpret the mind, the aspiration, the object, and longing of his people" to the broader community. Roscoe's newspaper had a different approach than other publications like it.

His editorial philosophy differed because he was a civil rights advocate, and the *Black Dispatch* was the mouthpiece he used to convey his messages. He was going against the white establishment, fighting Jim Crow laws, and was practically fearless in what he had to say. He attacked racial discrimination in all of its forms from anyone and anywhere, even the governor of the state. If he determined that their treatment of African Americans or anyone else was not justified, he made sure it was known and strongly endorsed that someone should be given a chance to survive and better himself without a foot holding them down.

The *Black Dispatch* anchored his leadership in the Oklahoma City Black community. It allowed him to pursue multiple interests and gave him the ability to define issues and to suggest solutions while helping to fight many legal cases related to that subject. Roscoe continued his well-respected newspaper until 1954. He also served as the president of the National Association for the Advancement of Colored People (NAACP) for thirteen years as he helped to pool resources to more effectively fight against discrimination and segregation.

Roscoe died in 1965 at the age of eighty-one and was inducted into the Oklahoma Journalism Hall of Fame in 1971.

> The policy of the *Black Dispatch* is not to publish stories of brutality and crime in the spirit of the yellow journalist. Every week we try to take the news field for subjects that will be inspirational to the race and promote and develop good citizenship …
>
> Roscoe Dunjee

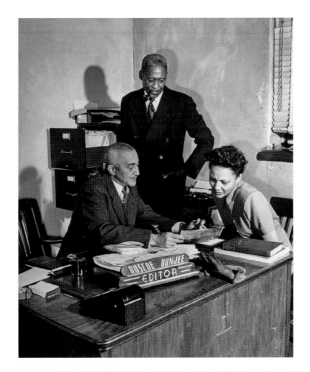

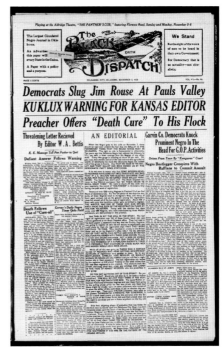

Above left: The Editor at University of Oklahoma Law School Roscoe Dunjee, going over some work with his fellow employees. Cornell Capa, *LIFE*, 1948.

Above right: Ku Klux WARNING for *Kansas Editor* issue from November 2, 1923. Editor: Roscoe Dunjee.

Roscoe Dunjee addressing a crowd at a parade, Z. P. Meyers/Barney Hillerman, 1942.

DUNJEE SCHOOL: HISTORY

In my research on the school, not much information was given, so I turned to the neighbors of the long dilapidating building. Walking around the neighborhood, it didn't take long to learn that there were still a lot of Dunjee graduates. You could pick them out from signs in their yard or bumper stickers. It was clear that there was a lot of pride from those who attended the school. From the little information found online and long interviews with residents, I was getting close to finding out why the school was abruptly closed with everything still inside.

Given Roscoe's inspiration and movement to the Black community in the Oklahoma City area, it's no surprise that a school would be established in his name. Spencer Oklahoma, just twenty minutes outside of the OKC area, opened the Dunjee All-School-Association or Dunjee Negro School System in 1947. The area was known as Green Pastures at this time and had an elementary school, middle school, high school, and a large field house shared by all three schools.

> I remember [in 1960] I started in the 1st grade, we went to the elementary school called "Parker Elementary" and that's where you started. And when you got in the 6th grade you went "up the hill" to the middle school. The middle school was in the front part of Dunjee and then you went to the back which was the high school.
>
> Eleanor Laskey (Class of 1972)

The residents of the Dunjee area had long suffered at the hand of segregation in Oklahoma. Before 1963, it was part of the Choctaw school system. Dunjee was most known for the great African-American teachers and their education, including civil pioneer/leader, Clara Luper. She is best recognized for her leadership role in the 1958 Oklahoma City sit-in movement. This was when she and her young children, along with many other young members of the NAACP Youth Council, successfully conducted nonviolent sit-in protests of downtown drugstore lunch counters, which overturned their policies of segregation. Luper continues to be remembered by her former students.

> Mrs. Luper would NOT let you fail. You would say "I can't do it" and she would say "what do you mean you can't? 'Can't' is not in your vocabulary." The education I received at Dunjee made me focus on who I was and where I was going in life. Our teachers knew that we had to have an education. They made sure you understood family and working together. They made sure that you had a foundation to stand on when you left Dunjee and that you had pride. That's what Dunjee was, the pride of that community.
>
> Sterling Mitchell (Class of 1972)

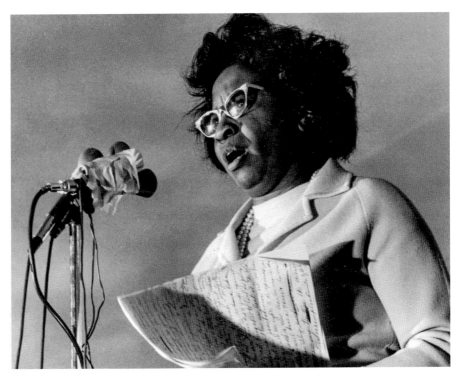

Clara Luper speaks at a rally on Oklahoma City's east side in November 1971. She passed away at age eighty-eight in 2011. [*Associated Press*]

After years of substandard support from the City of Choctaw, they fought to be integrated into the Oklahoma City school system and won. However, in 1972, the school board closed all Dunjee schools and began bussing as part of the mandated laws of desegregation. The community was stunned. Having suffered for years at the hands of the Choctaw Public School system and fighting to get a better education for their children under OKCPS, the community received another blow when their beloved Dunjee school closed as a result.

> The community was alive when Dunjee was there. They did more than just close the school down, they closed our community.
>
> Don Roberts (Class of 1971)

With that knowledge, I now knew the school was abandoned in 1972, but that didn't answer why I was seeing dates from 2004 on the whiteboards. After digging through more files in the drawers and talking with more neighbors, I discovered a noted civil rights activist, Theotis Payne.

THEOTIS PAYNE AND DUNJEE ACADEMY: NEW BEGINNINGS

Payne graduated from Dunjee High in the last year it was open, 1972. Upon receiving his diploma, he was passionate and knew that he could one day reuse his old school.

Theotis sought to purchase the Dunjee school in 1996. He opened the school as Dunjee Academy, a charter school. Because the OKCPS had re-opened the former Dunjee elementary, the academy served only grades 6-12, and had an enrollment of thirty-fifty students at one time. Their hope was to help at-risk students who had behavioral problems and those considered "high risk" by the OKCPS. They operated on a one semester contract basis.

With all the great things happening for the school and the students, in the early 2000s, Theotis started having complaints that educators employed at the school were not certified. According to the *Daily Oklahoman*, on September 26, 2003, the OKCPS quickly placed the school on a five-month notice, meaning that if they did not improve the conditions at the academy the OKCPS would withdraw funding and push for the closure of the school. More complaints began to arise about Theotis Payne after he was charged with several DUIs in the coming months.

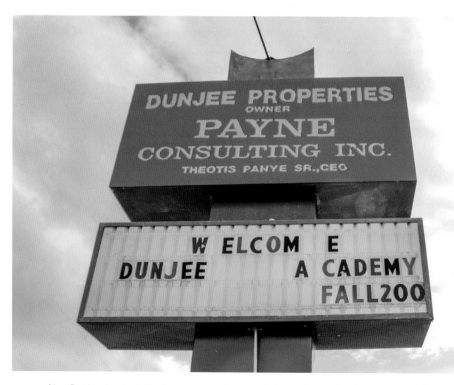

New Dunjee sign added by Theotis Payne in 1997. Welcome Dunjee Academy. [*Michael Schwarz, 2011*]

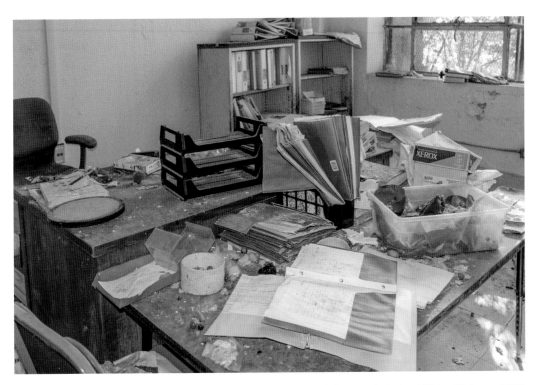

Art classroom, records saturated with water from years of a partially opened window. [*Michael Schwarz, 2011*]

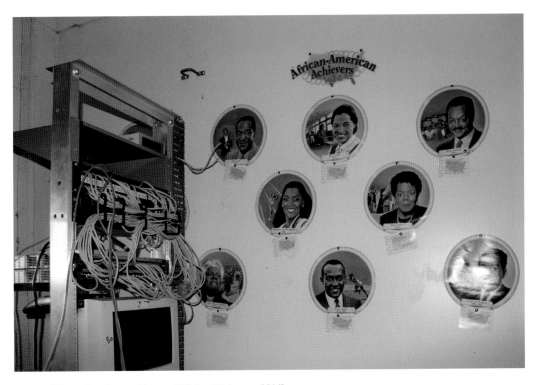

African American achievers. [*Michael Schwarz, 2011*]

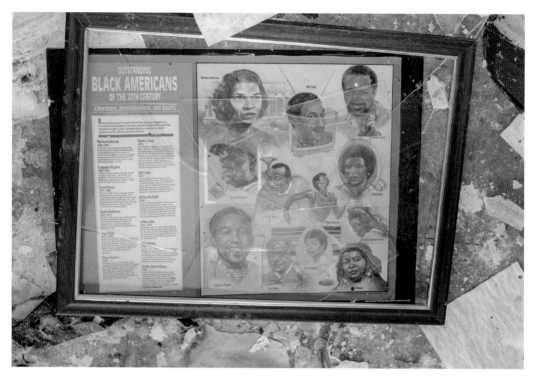

Broken frame of an Outstanding Black Americans of the twentieth-century educational poster. [*Michael Schwarz, 2011*]

One of the many posters on the wall. [*Michael Schwarz, 2011*]

Board Vice Chairman Joe Clytus said Thursday he is opposed to the renewal of a contract with Dunjee Academy under the direction of Theotis Leon Payne Sr., who is a contractor with the district. Payne, 49, was arrested Monday on complaints of possession of a controlled and deadly substance, possession of drug paraphernalia and defrauding an innkeeper.

<div align="right">Michael Bratcher, Daily Oklahoman, Sep. 23, 2003</div>

The OKCPS was forced to withdraw their funding at the end of the 2003 fall semester. Based on the people I spoke with, and my online research, it still was unclear if Theotis ran the facility through other sources of funding or if it was officially closed after they lost their contract. By evidence of the assignments of the board I keep referring to, I can safely assume that the school ran another half semester, give or take.

Regardless if it remained open after they lost funding or not, it still doesn't answer my question: why was everything left inside?

Signed photograph of a school field trip to the Oklahoma State Capitol. Theotis pictured on the 4th step on the right. Photo found on his desk. [*Michael Schwarz, 2011*]

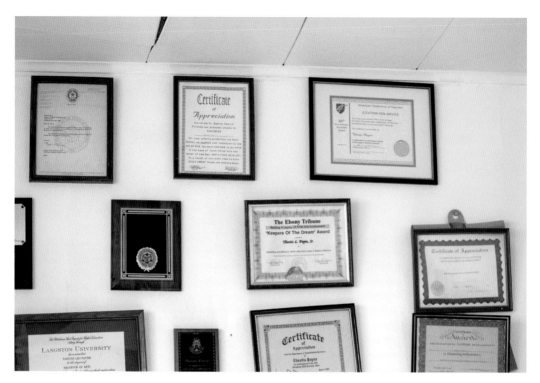

The many awards and certificates of Theotis Payne that were still hanging on the wall. [*Michael Schwarz, 2011*]

Study hall classroom. [*Michael Schwarz, 2011*]

Finding Out Why

More often than not, when places are abandoned, they rapidly become a haven for the homeless or a new place for vandals and thieves to obliterate everything in sight. Given that, on my first visit, I found it odd that there was no graffiti, nothing was broken, and everything was still in its place. When I researched online and talked to the former students, it became very clear: there was a mutual respect for this building in the community. So much pride and love came out of here and it was a place respected by everyone who walked its halls, now including me. It's funny to think that I became emotionally attached to a building, but when I think of how Dunjee came to be, the people who went there, and what they went on to do with their lives, I understood why this history was important. That's why on January 3, 2012, my heart sank.

All my friends must have known how I felt about Dunjee because I started getting texts from all of them. "DUNJEE IS ON FIRE!" Turning on the news I watched as the yellow flames jumped off the screen. After what must have only been thirty seconds, I found myself in my car and speeding toward what I knew was a nightmare.

Arriving on the scene, it became real. The fire had become a simple smoke and the firefighters were still pouring water on the structure to prevent the flames from reigniting. I didn't have to wait long before fire crews finished up and left the crumbling memory that was now covered with ash. I stepped behind the caution tape to see the damage. Only a few burnt pages remained of the library that was once full of books. English and history rooms were drenched while the entire ceiling nested over the floor and desks. Unrecognizable is a tame way to put it. While looking through the rubble, I ran into a woman. She was visibly upset and walked gently around the soggy remains with her hands in her pockets and her head down.

After I told her who I was and that I was not with the press, she agreed to let me follow her around as we both discovered more treasures destroyed by the relentless fire. As requested, I will leave her name out, but it turns out, not only was she the owner, she was also Theotis' wife. She was telling me stories as we passed each room and I finally got around to asking, "Why was everything left?"

She replied, "After we lost funding in 2003, we stayed open until Theotis died in 2004. After that, I just couldn't keep up with it and I decided to close it in the middle of the semester." She then went on to tell me this place was his passion and everything about him was represented within its walls. She didn't have the heart to take any of it down. Hearing that, it was hard to remember the negative press I read about. From what I remember, his widow wouldn't say much about that, nor did I want to ask given where we were and what just happened.

Rock facade from the rear of the school. Original chimney has been out of commission since the 1970s. [*Michael Schwarz, 2011*]

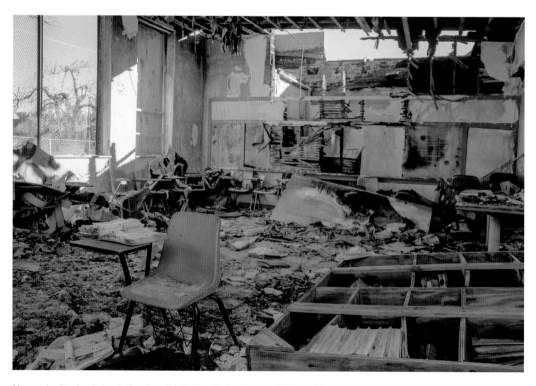

No words. Dunjee School after fire. "Math Vocabulary" room. [*Michael Schwarz, 2012*]

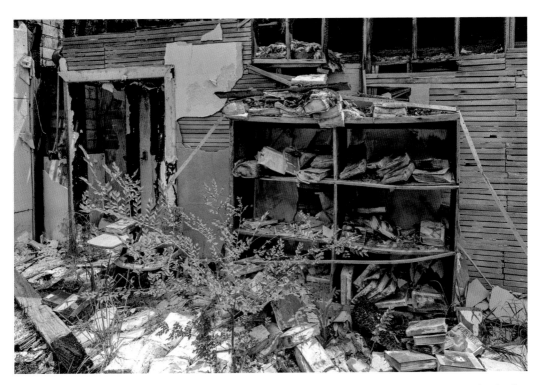

Oklahoma history classroom. Vegetation along with burnt and molding books from several years after the fire. [*Michael Schwarz, 2020*]

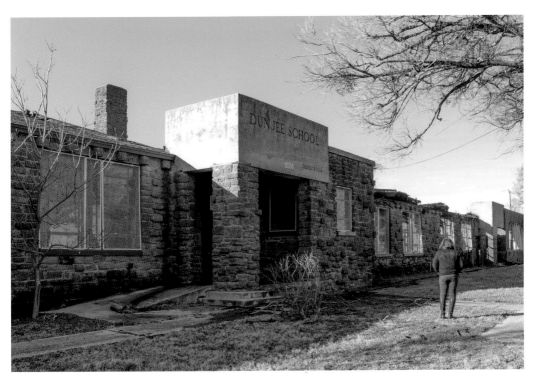

Mrs. Payne walking the outside of Dunjee shortly after the fire. [*Michael Schwarz, 2012*]

It was at this moment I fully understood the relevance of historical preservation. Understanding where we as a civilization came from and how we got here is done easily by asking the question, "Why?" It's important to educate ourselves of not only our own history, but reading and understanding where others are coming from at the same time. The fire and meeting Mrs. Payne changed my outlook on "just taking pictures of cool abandoned places." By taking the photographs of Dunjee before the fire, the reminder of days gone by can live forever on the internet. I'll never forget what she said to me that day: "Thank you for taking these pictures when you did. Most of my last, tangible memories of Theo were in that fire. At least I can look at those to remember him by."

Had I never curiously stepped into the abandoned Dunjee school, I may never have known about some of the strong roots and leadership that helped Oklahoma's civil rights movement. Not a day goes by that I don't wish I could go back to see Dunjee before the fire one more time to see what else I might have found. To this day, it remains to me as the greatest explorations I've ever been on.

I know there is still more to learn about this school and that's why I wish I would have gotten Theotis' widow's email or contact info. After the day of that fire, I have never been able to find her, even after extensive internet searching. Even several years later, I went to the 2016 reunion continuing to look with no luck. I did, however, meet Theotis' sister, Carmeletta.

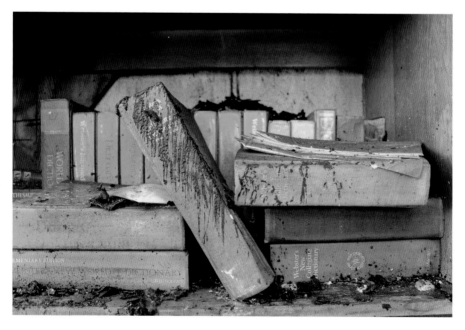

Archaic decay. The day I'll never forget. [*Michael Schwarz, 2012*]

My brother [Theotis] had a big heart and wanted to teach these students and prepare them for life. He was very organized and was able to recruit a lot of teachers, including our mom, with the same value. These kids that had fallen from the school system needed help, and they wanted to be there. They skipped all the time at public school, but they wanted to be at Theotis' school every day.

<div align="right">Carmeletta Payne McCullough</div>

END OF THE SCHOOL, NOT THE PRIDE

After the fire, the building became open to the elements and the vandals/thieves were starting to make their way to anything that could be destroyed or stolen. The former Dunjee was only a shell of its former self.

The idea of Dunjee remains through Roscoe, Clara Luper, Theotis Payne, and everyone who took part in making that school the foundation and cornerstone of the fight to the desegregation of Oklahoma City. To this day, Dunjee's halls are only filled with memories. Residents hoped for the day when it would once again be a functioning part of the community, but those days are long gone.

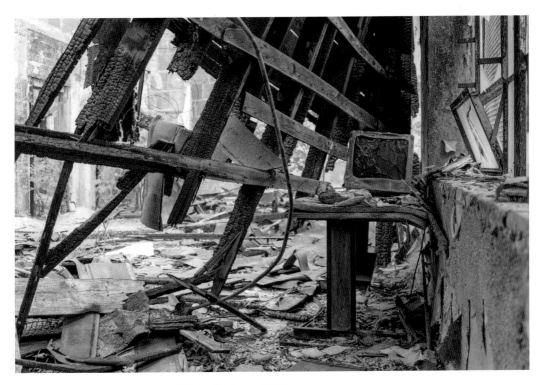

A melted computer screen. [*Michael Schwarz, 2012*]

Desk in the charred hallway with new life taking shape. [*Michael Schwarz, 2016*]

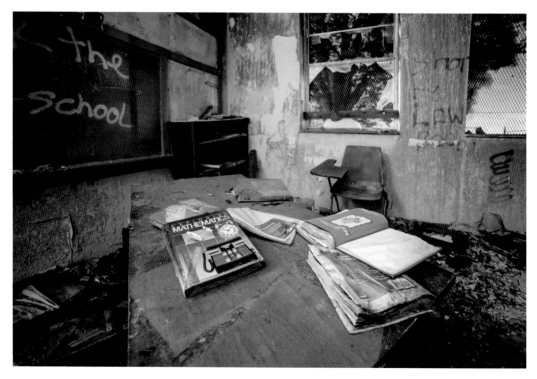

Math textbooks on the teachers molded desk. [*Michael Schwarz, 2016*]

2

FROM RUINS TO REASON: THE JOURNEY

Emily Cowan

I n high school, history was my least favorite subject after math. I never paid attention; in fact, I specifically remember my Oklahoma history class in freshman year being my napping hour. I crammed for tests, finished projects last minute, and somehow still managed to make it out with a decent grade. I didn't get into it until I was around sixteen, searching the internet for cool places to visit in Oklahoma. I had found the website AbandonedOK.com, and immediately I dove down the rabbit hole scrolling through post after post after post until I came across Skedee School, only an hour away.

My friend Jonny and I packed up and off we went to see this school that had been abandoned since 1967. We drove into the town marveling at the Bond of Friendship monument between Colonel Ellsworth Walters and Chief Baconrind. We made a left and pulled into the gravel area in front of the school, and in we went. I could not believe my eyes—there was still so much stuff. I had always driven by abandoned buildings and houses, but they were never much more than that to me. They were never the place someone graduated, met the love of their life, or had brought home their first child. A million questions started running through my mind: Why was this abandoned? Why was nothing being done with it? Why was there so much stuff left?

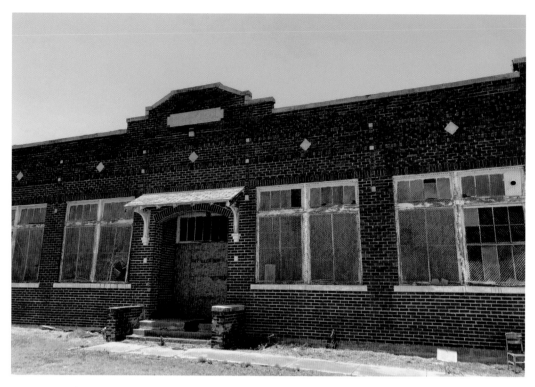

Skedee High School. [*Emily Cowan*]

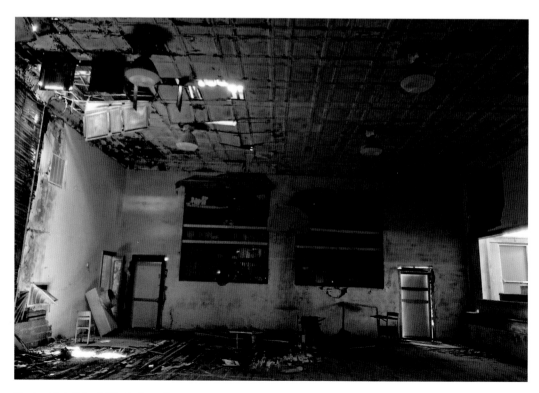

Skedee High School. [*Emily Cowan*]

I went home and for days continued to search the website, but since it had been down, I decided to do my own spin on researching and photographing places and posting them on my Instagram (@emilyecowan). It started as just a small fun hobby for days I was bored, and then the day after my nineteenth birthday, I woke up to a message from Abandoned Oklahoma on my Instagram, "Hi Emily! I saw your comments on a few of our pictures and have been looking at a few of yours. Would you be interested in contributing/joining the AOK Team?" I almost fell out of my bed. I started fangirling and thought, surely, I am still asleep. From there on out I started forming a friendship with the director, Michael Schwarz.

A few weeks later we went out on our first road trip. Our best stop that day was Marshall School. Walking in, I started looking around the front lobby area while Michael took off to the left. I followed, walking into the biggest auditorium, and we decided that this would be our comeback post on the website. I learned a lot in those few months about how to run a website, coding, web design, and how to improve my writing skills. I developed a newfound love for history through the site, a history class that I was the teacher of. For the first few months, I mostly worked on articles. I couldn't believe there was so much history behind these buildings, and that some of them were not taught in Oklahoma's history curriculum, such as the Tallchief Mansion and Gray Horse School.

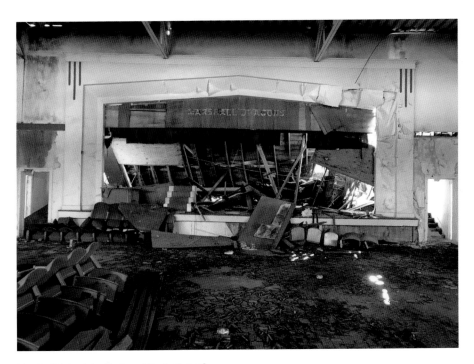

Marshall School Auditorium. [*Emily Cowan*]

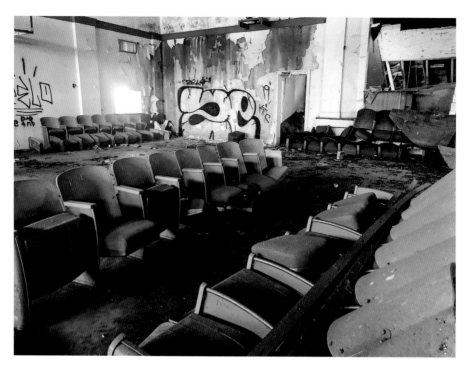

Marshall School. [*Emily Cowan*]

Tallchief Mansion was a place I had seen posted on Facebook multiple times. I had gone to it for the first time on my birthday trip a few days before Abandoned Oklahoma reached out to me. At the time, I would only take a few shots that would look good on my Instagram and then do a quick Google search for a small bit of information to post as a caption. Michael and I later went back to take more pictures, and then I started writing up an official article for the website. I found out that the Tallchief family was not only prominent throughout Fairfax history, but Oklahoma and international history as well. Maria and Marjorie Tallchief had lived in the home until they were seven and eight. Both girls went on to become world renowned prima ballerinas. They were honored throughout Fairfax and Oklahoma, and yet I had never heard of them until I did the research and digging myself.

Gray Horse School is in the small town of Gray Horse, Osage County. In the 1920s and 1930s, Gray Horse was at the center of the oil boom, creating a surge of wealthy Indians, but with this came darkness and terror within the community. Murders of Osage Indians were being committed by people after their wealth, which led to the birth of the FBI. Everyone knows what the FBI is, and I still had no clue about the correlation with Oklahoma. This was a turning point for me; it sparked my need to educate the people of Oklahoma on these historic buildings that were just being left to sit and rot away.

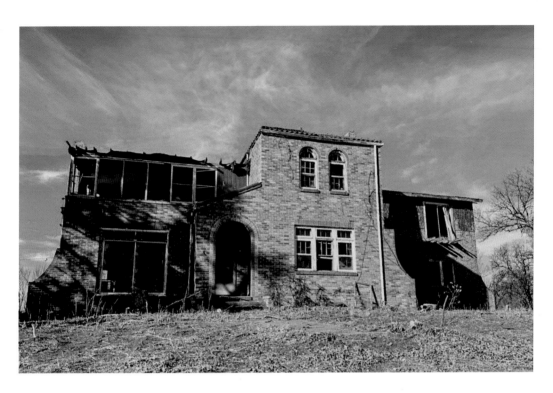

Above: Tallchief Mansion.
[*Emily Cowan*]

Right: Gray Horse School.
[*Emily Cowan*]

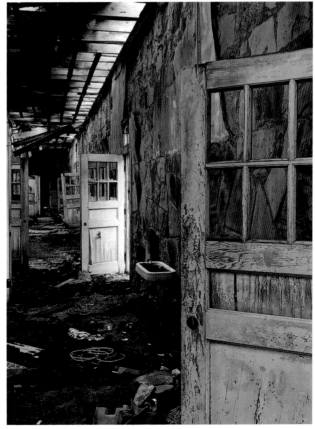

I indulged in my writing and research; I was obsessed with knowing more about the history of our state. I was generally a shy and awkward person who struggled with talking to new people. When reading the articles as a viewer of the site, I loved seeing the personal stories included, because they made me feel a deeper connection with and understanding of the buildings I was looking at. My first interview was in an active church. Michael and I, on our first adventure together, went to Waukomis Middle School to find the owner again for permission. The Waukomis Christian Church next door had just let out their Sunday morning service, so we headed over to see if they knew who to contact. There, we met Pastor Dave and Linda Jones, the owners of the church. We told them who we were and what we do, and we all had a lengthy conversation. They showed us an area on the building where the original wood from 1897 still exists and rang the old bell for us. We all talked about the devastating events happening across small towns in Oklahoma—the tearing down of the old and building of the new. This engaging conversation made me love interviewing people.

OKLAHOMA HISTORY RESCUE: FROM REASON TO REALITY

It still did not make sense to me how these buildings of historical significance, so interesting to our state, could just be left to rot. Michael and I continued to go on trips. In March, we went to a small town called Cogar, Oklahoma. We set out on a quest to see the famously photographed W. S. Kelly General Merchandise, featured in the 1988 movie *Rain Man* with Tom Cruise. We pulled into the lot across the street around 11 a.m. and started taking our pictures. It was such a beautiful place. We noticed someone pull into the driveway of the house beside it and we headed over to ask if he knew anything about the place. This started our relationship with Carl Lehman, the owner of the historic store. He agreed to give us a tour of the inside. When we walked in it was like nothing I had ever seen before. It was like stepping into a time capsule from the 80s, with old soda cans and bottles, polarized sunglasses, medicine, mechanic parts, etc., all left right where it was when the store closed. We went home that day and for almost four hours dreamed up plans on how to save this place. This started a new passion in me and for Abandoned Oklahoma; along with documenting and educating, our mission now included efforts to save Oklahoma's history.

As I passed through the aisles of the cluttered front room, merchandise strung all over the shelves, visions of what could be cluttered my head. I was so overwhelmed with the thought of "I wish I could revive this place" that I barely took any pictures. And as we said goodbye to Carl and got his information, I was overtaken with the excitement of the amazing experience.

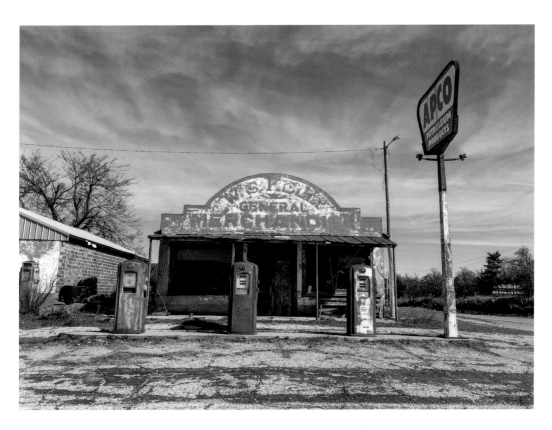

Above: W. S. Kelly General Merchandise.
[*Emily Cowan*]

Right: Bennett gas pump at W. S. Kelly.
[*Emily Cowan*]

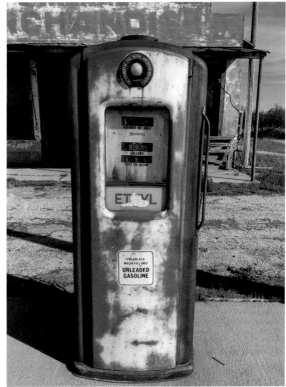

This was the turning point for me. I wanted to do something more than document history—I wanted to save it. After ending our adventure that day, we called each other to brainstorm for the next four hours of how we could make this restoration dream come true. "We could repaint the sign … and add a picnic area between the buildings! Maybe add a mural to the side?" After the conversation ended, I couldn't help but feel like this was all too good to be true. I didn't want to let my excitement cloud my judgment of reality. I remained hopeful and ambitious, but tried to reserve my enthusiasm.

Within the next few weeks, Michael and I started working. Just the two of us and our equipment headed back to Cogar. We got right to work cleaning up debris from where the ice plant once stood in between the garage and W. S. Kelly. We had remembered Carl telling us about a two-piece sign depicting "Lehman's & Son Grocery & Sta." that once stood proudly on the front of the building. "Hey Carl, you said you still had those signs, do you remember where you put them?" I asked.

He pondered for a second, "They must be somewhere out back in the goat pen." Michael and I looked at each other apprehensively. We walked around the store to the goat pen. "They were set over there somewhere," Carl hollered. Not seeing any visible signs in the direction he pointed us in, we hopped the fence and made friends with the goats. (They must've really liked me, because I almost lost part of my shirt to some of them.) We noticed an inconsistency in the dirt and took a shovel to the ground. *Chink*! Feeling like Indiana Jones, we had hit something metal. Digging up the edges, we determined it was, in fact, the sign, with what had to have been a daunting fifteen to twenty years' worth of dirt sitting on top of it. So, I thought back to my roots of growing up on a farm when I was younger and got down in the dirt in the name of saving history. It took us around two hours to fully unearth both signs and bring them inside the main building.

In the following weeks, we started gathering volunteers and set the date for our first big volunteer day, June 20, 2020. We anxiously counted the days and gathered the materials needed such as the paint, wood, shovels, trash cans, etc. I was more than excited because I was given the task of repainting the sign on top of the building—nerve-wracking because I wanted to impress, and because I would be standing on a slanted tin facade that was not the sturdiest. Let's just say Michael was quick to have me sign an "I won't sue if I fall off" contract. It took all day with a majority of my time spent trying to map out how the letters looked, since a lot of the paint had chipped away. But all in all, it was a success amongst the group and we were able to completely clean the inside as well as a lot of the outside.

Right: Emily Cowan volunteering at W. S. Kelly General Merchandise.

Below: Emily Cowan volunteering at W. S. Kelly General Merchandise.

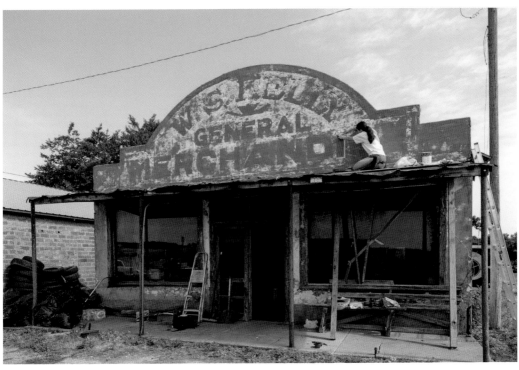

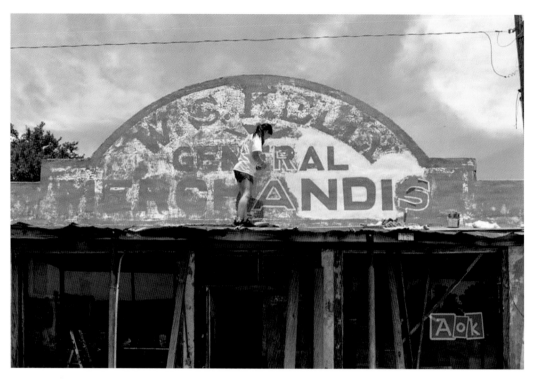

Emily Cowan volunteering at W. S. Kelly General Merchandise.

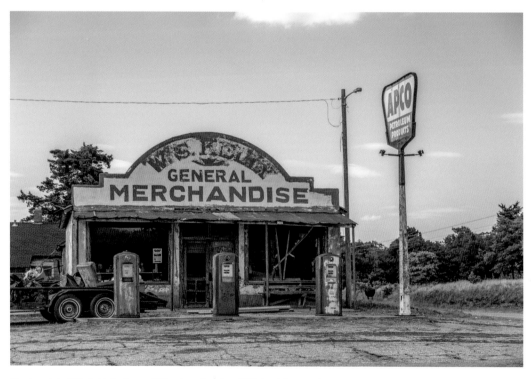

Newly painted W. S. Kelly General Merchandise sign. [*Michael Schwarz*]

Then came the task of finding the history. As much as W. S. Kelly General Merchandise has been posted on the internet, the only piece of information I could find in the sea of posts was, "It was in the movie *Rain Man*!" Now, going back to our first and follow-up visits with Carl, we started to form part two of this four-part story.

W. S. Kelly General Merchandise

Wilbur S. Kelly built the General Merchandise store in the mid-20s in what was known as "New Cogar." He ran the store for a short period of time before moving to California, where he became very successful with gas stations. According to Carl Lehman, who grew up knowing Mr. Kelly, "He used to tell us Pretty Boy Floyd would come in the store back then as the country was full of crooks and bootleggers. He always said that Floyd was a nice gentleman, but he would come in with a fellow named George Birdwell and he was scary, wouldn't mess with him." Kelly sold his store before moving out to California to Roy Bassett, who had owned Roy Bassett General Merchandise in Old Cogar in the early 1930s. The Bassett's were looking to move to New Cogar for better business along highway 152.

Michael was able to track down a descendant of Roy Bassett, Duff Bassett. Duff happened to have old photographs of the new Roy Bassett General Merchandise that resided in the W. S. Kelly General Merchandise store. We learned new information through Duff about his family's history in the store and through newspaper archives.

Roy Bassett General Merchandise

When the Bassett family moved into the W. S. Kelly in the 1930s, the store advertised "Lab Tested Superior Feeds" on the side. The Bassett family, having previously successfully ran the post office in their general merchandise store in Old Cogar, got the post office moved into their new store. Amy Bassett, Roy's Wife, was postmaster in the store. According to *The Verden News*, Nov. 19, 1948, Roy Bassett's Store was used as an election polling station as well.

Searching through more newspaper archives and talking to Carl and Duff, we were given another name, Jesse H. Schrantz. I was astounded how much history was in this little store, but it now made sense to me why no one else really had any information on it. I felt like I could be a new tracker for Ancestry.com with how many family histories I was searching through.

Jesse H. Schrantz Store and Station

Roy Bassett leased the general merchandise store to Jesse H. Schrantz in the early 1950s. It then became known as Schrantz Store and Station. Jesse became postmaster when taking over the store until it was discontinued on September 30, 1954. Post office boxes were later removed and replaced with hardware cubby holes by the Lehmans, but the post office safe remains inside. Schrantz operated the business up until 1958, when he moved his family to Colorado.

Now we were nearing the end of the first story for this incredible store of the century. Carl Lehman's family were the longest and final owners of the W. S. Kelly General Merchandise.

Lehman's & Son Grocery

Carl Lehman was eight years old when his father bought the store in 1958. A dilapidated bench sits in front of the store. "I can still remember sitting on this exact bench when I was a kid. I'm pretty sure a neighbor built this for Wilbur Kelly. It's been here as long as I can remember." Carl Lehman reminisced sitting proudly on the half-dismantled bench. The Lehmans, like past families, resurrected a sign up on the tin roof reading "Lehman's & Son Grocery" and left everything else the same. They continued selling groceries, farm accessories, fishing supplies, tools, and other "general merchandise." Carl and his family would close the store on Christmas every year to repaint the floors just in time to bring in the new year. "This is where I grew up. I've seen so many people coming in and out of this store," Carl mentioned while giving us a tour. "We had a few break-ins in the late 60s. Someone stole some gun ammo and fishing poles, but didn't get too far because their car broke down 3 miles out of town."

This little store ended up not only serving as a merchant for goods, but also serviced cars, became a bus stop for nearby towns, and of course, sold APCO gas and oil products. This started a few years into the new ownership, given that APCO was founded after Anderson-Prichard Oil Corporation (founded 1922) was officially permitted to use the acronym in 1960. The Lehman's sold on average 30,000 gallons monthly until 1973. "They [APCO] cut us down to about 7,000 gallons a month." All supplies from the APCO Oil Corporation slowly diminished over the next six years until the oil company completely dissolved in 1979. The Lehmans were able to keep the store open one year after that before the loss of APCO put them out of business. "We just locked it up and left everything how it was," said Carl.

Although this was the end of the W. S. Kelly as a functioning store, the tiny town of Cogar gathered around it in 1988 when the movie *Rain Main* brought in two movie stars to film.

1988 RAIN MAN FILM

The movie starring Tom Cruise and Dustin Hoffman features two brothers traveling across the country. One of the filming locations took place at the W. S. Kelly General Merchandise APCO Station in the tiny town of Cogar, Oklahoma. In the scene featuring the Lehmans' store, the two stars stop at the phone booth to make a phone call. The phone booth was a prop put in place by the producers. The scene was filmed on June 2, 1988. About 100 folks from all over came out to watch the filming and meet the stars. "Dustin Hoffman went out of his way to make people feel good about being there. I heard him [Hoffman] say we was a pretty good bunch," said Richard Allen, a longtime resident of Cogar.

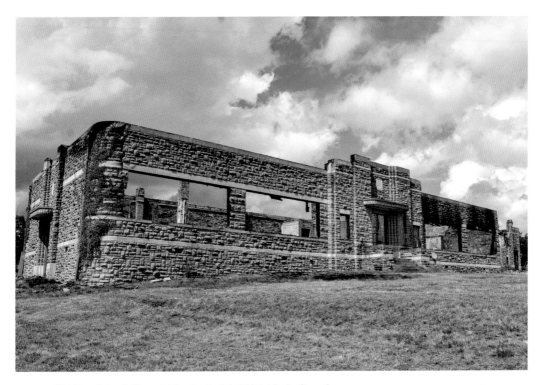

Old Prue School after catching fire in July 2020. [*Emily Cowan*]

Knowing that we were not only helping the families attached to this store but also helping the town by restoring it is a feeling I will never forget. Everyone was so appreciative and thankful for us having a vision and working towards it. I wanted this history rescue project to expand further than just Oklahoma. This is how Abandoned Kansas started. Since I was born and raised there during my childhood years, I was never quite old enough to understand the history that my hometown held. Now that I am older and often drive back to visit family, I took on the mission of exploring and educating myself and other Kansans of the deep history rooted in the state. From the Sumner and Monroe Schools that were at the center for Brown v. Board of Education, to the White Lakes Center, which was revolutionary in changing shopping across the Midwest.

Now, I am looking forward to helping successfully renovate the W. S. Kelly General Merchandise and taking on more projects with Abandoned Oklahoma. I want to continue to grow our database of locations and be a source for others wanting to learn about their state's history, by encouraging people to get out and explore, do more to help preserve their history, and change the outlook on the urban exploring community.

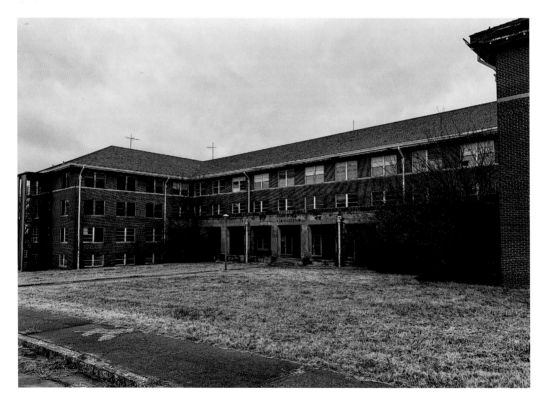

Ada's Hall Administration Eastern State Hospital. [*Emily Cowan*]

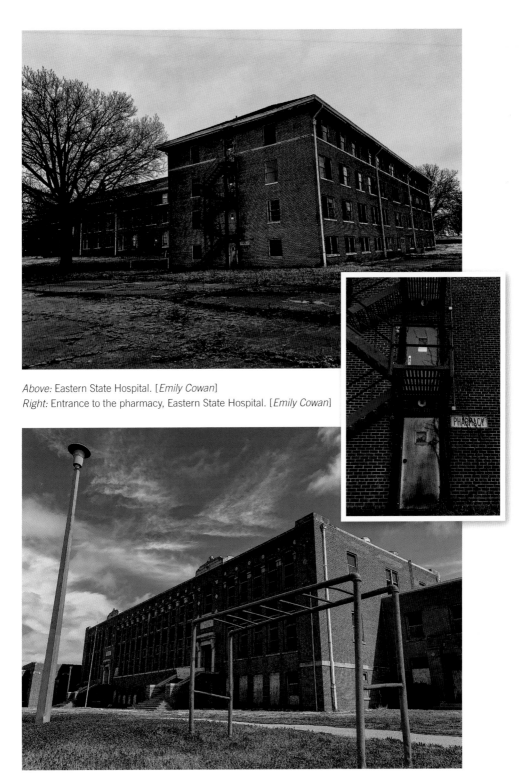

Above: Eastern State Hospital. [*Emily Cowan*]
Right: Entrance to the pharmacy, Eastern State Hospital. [*Emily Cowan*]

Columbus Elementary School. [*Emily Cowan*]

Columbus Elementary School. [*Emily Cowan*]

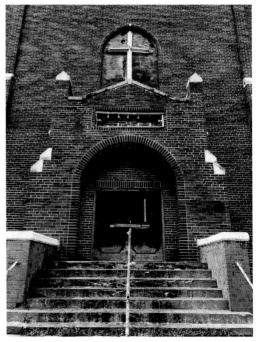

Above left: Boynton Armory featuring remnants of the Cardinals basketball games. [*Emily Cowan*]

Above right: Mt. Pleasant Baptist Church before October 2020 fire. [*Emily Cowan*]

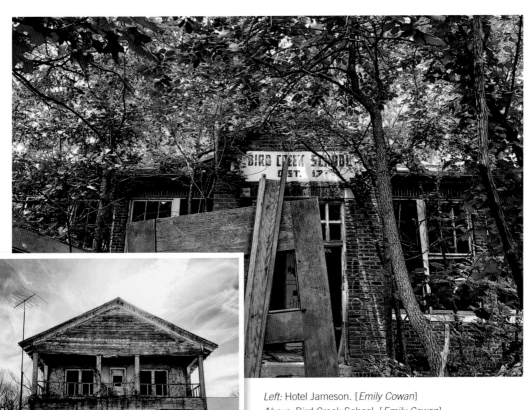

Left: Hotel Jameson. [*Emily Cowan*]
Above: Bird Creek School. [*Emily Cowan*]

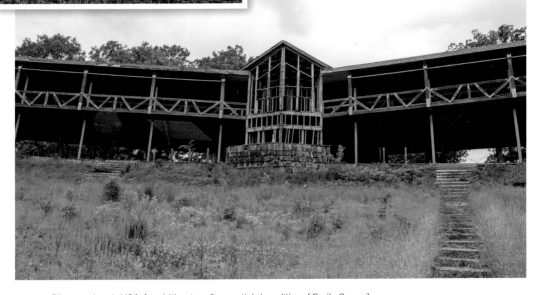

DiscoveryLand, USA Amphitheater after partial demolition. [*Emily Cowan*]

3

LINDLEY HOSPITAL

Jennifer Burton

The city of Duncan is located in Southwest Oklahoma and has been the birthplace of many things from a huge oil business to a well-known celebrity. Due to the booming oil culture and the refinery in town, in the 1920s, Duncan was a quickly growing community. After recovering from the devastating days of the depression and the years that followed, by 1970 Duncan had a population of roughly 20,000 people. Duncan was the nearest city for many of the surrounding communities and is where people came to get their necessities and for their health-care as well. Duncan was equipped with three hospitals. Lindley Hospital was one of the medical centers that provided healthcare services for the town.

Lindley Hospital opened in 1937 and had around thirty-five beds inside its walls. The hospital was owned and operated by Dr. E. C. Lindley and Dr. E. H. Lindley. The two doctors wanted a hospital that offered the community another option for quality healthcare and opened the private hospital to meet the needs of the growing towns in Southwest Oklahoma. Lindley Hospital, along with the other two hospitals in Duncan, provided peace of mind for the people of Stephens County, knowing that medical help would be available when needed. For several decades, the three hospitals in Duncan offered the town and the surrounding area the medical care that was essential for the survival of any smaller community. Having options for health needs was rare in a smaller town and Duncan had plenty to choose from.

Duncan also resonates in the hearts of its residents long after they have moved out of town. In the spring of 1954, Jean Speegle Howard, an American actress, traveled back to her hometown of Duncan, Oklahoma, to give birth to her first son, Ron Howard. Her husband, Rance Howard, was in the Air Force, and Jean wanted to have her baby in her hometown instead of the base hospital in Biloxi, Mississippi,

Lindley Hospital. [*Jennifer Burton*]

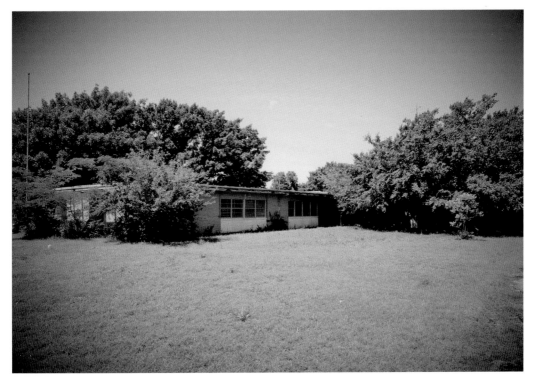

Lindley Hospital. [*Jennifer Burton*]

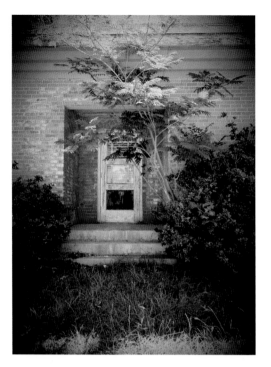 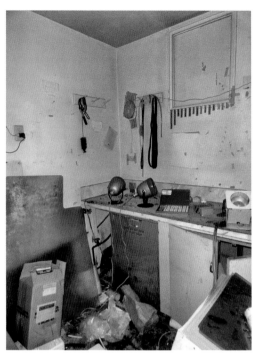

Lindley Hospital. [*Jennifer Burton*]

Lindley Hospital. [*Jennifer Burton*]

where the family was stationed. Born on March 1, 1954, in Lindley Hospital, Ron Howard went on to be an extremely well-known American actor and filmmaker. In December of 2018, Mr. Howard posted a picture on his personal Facebook page of himself standing outside on the abandoned grounds of the hospital he was born in. He was quoted as saying that even though he never lived in Duncan, the building made him feel connected to the town.

In the early morning hours of December 22, 1957, a fire broke out in the kitchen area of the hospital. The fire destroyed the hospital and caused around $200,000 dollars in damage. Twenty-five patients and three small babies were all unharmed and moved to other area hospitals. Hospital records, some of the medical equipment, and a free-standing clinic next door were saved from the fire. The fire devastated the building, and afterwards, the fate of the hospital was unknown due to the extent of the damage.

Three local doctors, Dr. E. C. Lindley, Dr. E. H. Lindley, and Dr. Dana Ryan became co-owners of what would become the new Lindley Hospital in June of 1958. Built at a cost of around $280,000, the new building would have double the space as the hospital that burned before it and would offer a total of fifty-two new beds. It would have twenty-eight comfortable rooms for patients that included twenty-one semi-private rooms and eight private rooms. In its day, it would offer an ultra-modern design and would have state-of-the-art medical equipment. It would also be a one-story brick building and would offer a new covered passage from the new hospital to the clinic that was unharmed in the fire. It would become a staple for healthcare in the community when it was completed.

Above left and right: Lindley Hospital. [*Jennifer Burton*]

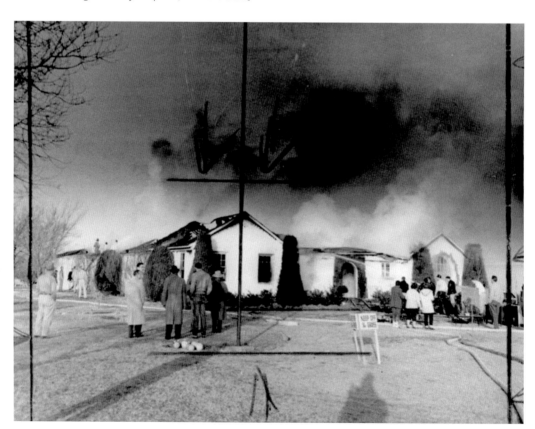

Lindley Hospital, the Gateway to Oklahoma History, 23 Dec. 1957.

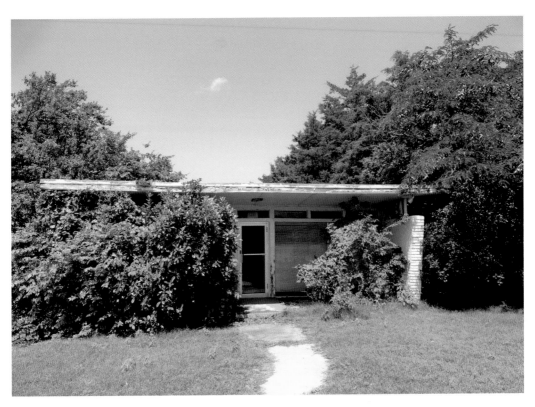

Lindley Hospital. [*Jennifer Burton*]

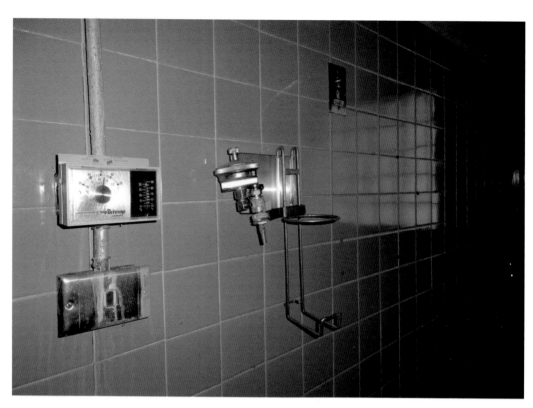

Lindley Hospital. [*Jennifer Burton*]

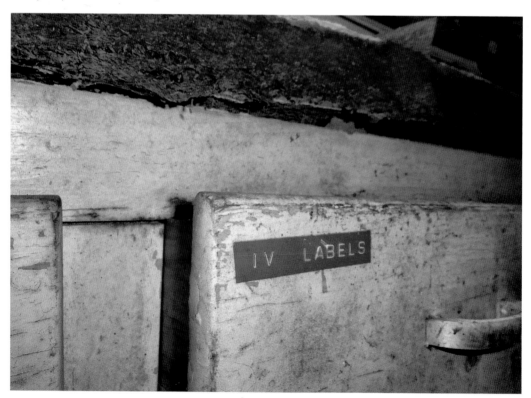

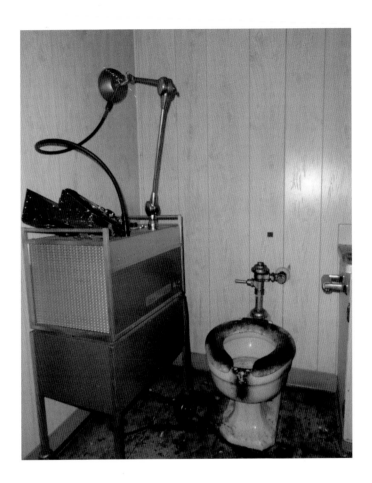

Lindley Hospital.
[*Jennifer Burton*]

On April 12, 1959, the three doctors that brought Lindley Hospital back to life invited the public to an open house so they could tour the new facilities and see what it had to offer the community. It has been said that 6,000 people walked the new halls that day with a sense of relief that the hospital had been rebuilt and was available to meet the needs of the residents of Duncan once again. The new hospital offered a nursery unlike any other in the area. The walls were painted with bright colors with sweet pictures of animals doing fun things like playing musical instruments. There were six clear bassinets for parents to be able to see their new babies better. The nursery was also equipped with an incubator and air conditioning. The hospital had around $500,000 worth of new equipment when it reopened. The main east and west wings were patient rooms. The kitchen and dining room were located on the north side of the building with the reception area and waiting room on the south side of the building. The new hospital had minor and major surgical suites that were located down the main corridor away from patient rooms.

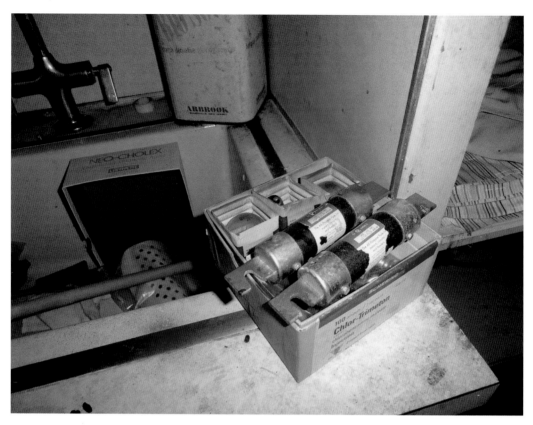

Lindley Hospital. [*Jennifer Burton*]

In 1977, Duncan Regional Hospital Inc. purchased the physical assets of Lindley Hospital along with the other two additional hospitals in Duncan. For many years, the three aging facilities had met the community's healthcare needs, but were no longer able to keep up with the areas rapidly growing industrial advances. The Chamber of Commerce in Duncan established a task force to make recommendations for the best plan for medical care in Duncan going forward. The task force recommended that the three hospitals merge into a single nonprofit medical center. That decision led to the formation of Duncan Regional Hospital, which continues to serve the community presently.

I have a personal connection to this former hospital. In the summer of 1979, my family gathered in the waiting room right inside the main entrance. My mother was pregnant with me and my due date had come and gone. While my family was patiently waiting, I was delivered via cesarean section in the major surgery suite of the hospital. Mom and baby were both happy and healthy. Two years after my birth, my mother was admitted into Lindley Hospital because of a serious bout with pneumonia, and my great grandmother took her last worldly breath there in 1980 as well.

Lindley Hospital. [*Jennifer Burton*]

Lindley Hospital. [*Jennifer Burton*]

Lindley Hospital. [*Jennifer Burton*]

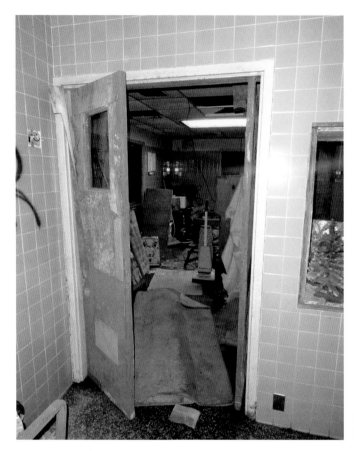

Lindley Hospital.
[*Jennifer Burton*]

Lindley Hospital officially closed in the early 1980s. It has sat unused since the day it ceased operations. I was welcomed in June of 2012 by the owner of the building to come to Duncan and see the old hospital for myself. Time had definitely taken its toll on the once modern building. The roof had leaked and there had been damage done by vandals over the years. However, if I looked close enough, I was still able to see the leftovers of what was there. The labels on the drawers and the leaded glass nursery windows were still there. The surgical light was still hanging from the ceiling in the surgery suite. That surgical light was most likely the first light my newborn eyes ever saw. Being inside the hospital gave me a sense of peace. Knowing that I was standing in the same room my grandparents and great grandparents stood in as they waited for me to be born brought back the greatest memories for me. It reminded me how lucky I am to not only have those memories, but how lucky I was to be able to see with my own eyes where they all started.

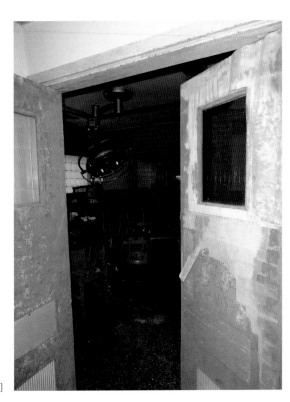

Lindley Hospital. [*Jennifer Burton*]

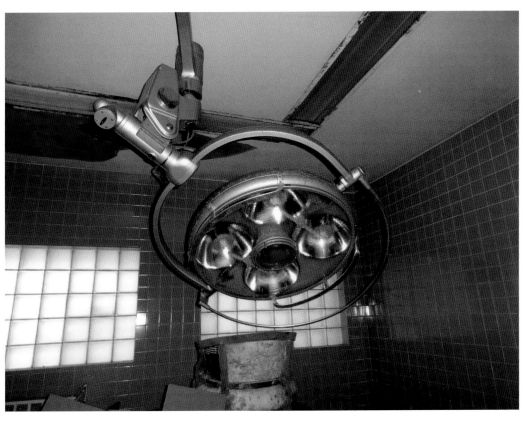

Lindley Hospital. [*Jennifer Burton*]

Disclaimer: Lindley Hospital is closed to the public and has an owner and caretaker. All photographs were taken with permission by the owner. There are currently no plans for the building.

4

TULSA SPEEDWAY
Johnny Fletcher

The Tulsa Speedway was situated in a field just off of Highway 75. This was not the start of the speedway, however. Previously, the Tulsa Speedway was located at the Tulsa State Fairgrounds. The racetrack was later moved to its permanent location in 1985. The track was originally built as a ½-mile track, but later shortened to a ⅜-mile dirt oval which featured many classes of cars from modifieds, stock cars, and even big-name sprint cars.

Sprint cars were all the rage in the racing community in the late 1980s. The Tulsa Speedway began its sprint car schedule in 1988. The track changed hands from many different owners and operators over the years and was the only nearby destination for Tulsa dirt track race fans to get their fill of motorsports excitement.

Mike Tucker shared his memories on AbandonedOK.com.

I grew up at that speedway. I couldn't wait for Saturday nights. I was probably around 10 years old when I first went to the track. I remember the likes of Buddy Cagle, Al Lemmons, Benny Taylor, Jackie Howerton, Harold Leep, Bill Sanders, and many others. I eventually was a vendor at the track selling pop and popcorn through the crowd but when the feature was about to start I was sitting watching the race instead of selling, got caught a couple of times, lol. I remember going out into the pits after the races to check the damage to the cars that had wrecked. I especially remember checking out the fiery wreck that killed Leroy Ellis and the time Al Lemmons went clear through the wall and hit a car in the parking lot. It must have been the late 60's and early 70s. I'll never forget the old Tulsa Speedway.

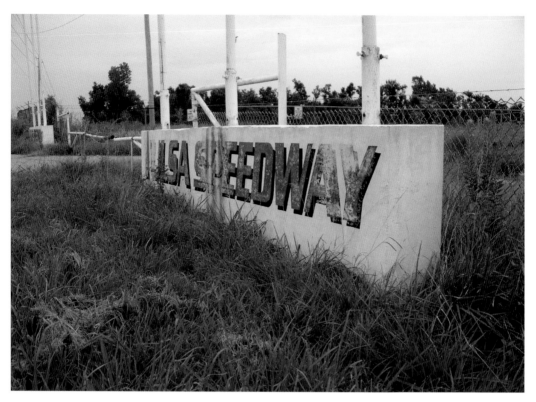

Tulsa Speedway. [*Johnny Fletcher*]

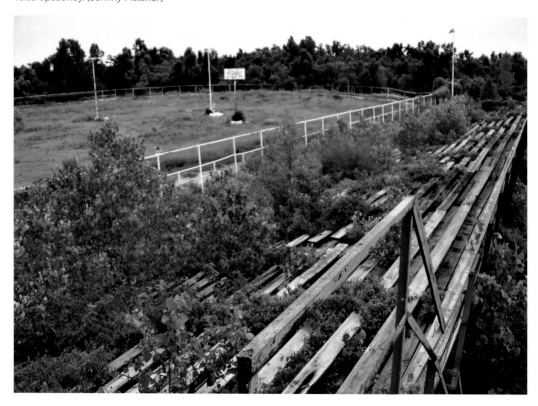

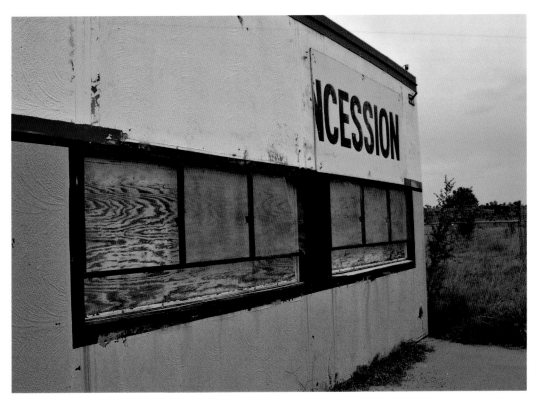

Tulsa Speedway. [*Johnny Fletcher*]

Tulsa Speedway. [*Johnny Fletcher*]

One major factor that contributed to the downfall of the Tulsa Speedway was its location. Race fans preferred the track in midtown and didn't want to make the drive to the new location just North of Tulsa. Another nail in the coffin was the splitting up of racing divisions. Which in turn led to fewer drivers and fewer car counts for each division. Drivers also complained of race winnings being too low to support their operations. The crowd attendance and operations costs soon took its toll on the track, causing it to shut down and lock the gates for good around 2005.

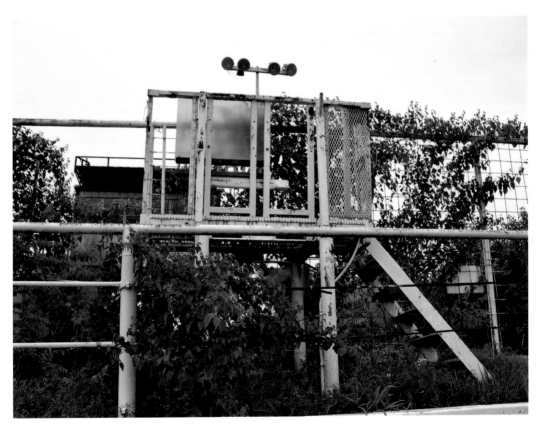

Tulsa Speedway. [*Johnny Fletcher*]

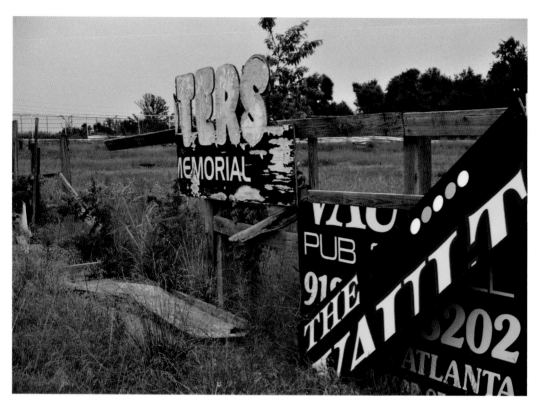

Tulsa Speedway. [*Johnny Fletcher*]

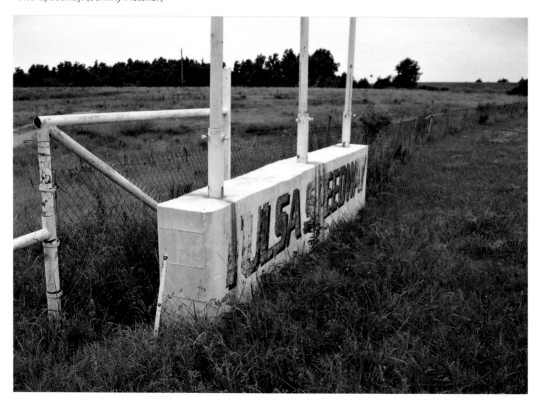

THE DAILY OKLAHOMAN, 2006: Lanny Edwards Says No to Tulsa

Tulsa Speedway was closed this summer, without a promoter and an uncertain future. The track has struggled ever since promoter Stan Durrett died in 2001. Edwards, who promotes races in Oklahoma City, Lawton, and Mesquite, Texas, has made a living at turning struggling racetracks into moneymakers. But Edwards said he has not given any thought to taking on the Tulsa Speedway, which once attracted open-wheel drivers from Oklahoma City for Saturday night races. "Oh no," Edwards said. "I have got as much on my plate right now as I can handle."

After Lanny Edwards passed on the Tulsa, nature began to reclaim the land with trees and weeds beginning to envelop the grandstands. Vandals began their assault as well, destroying the concession stands and breaking toilets in the restrooms. Sometime after 2015, the Tulsa Speedway had its final breath and was officially demolished without any news or rumors. It was almost done in secret, disappearing into history. The once towering announcer booth, grandstands, and the concession buildings were no more. The only remaining evidence as of 2020 is the white front gate pillars covered in vines with the fading words, Tulsa Speedway.

Tulsa Speedway. [*Johnny Fletcher*]

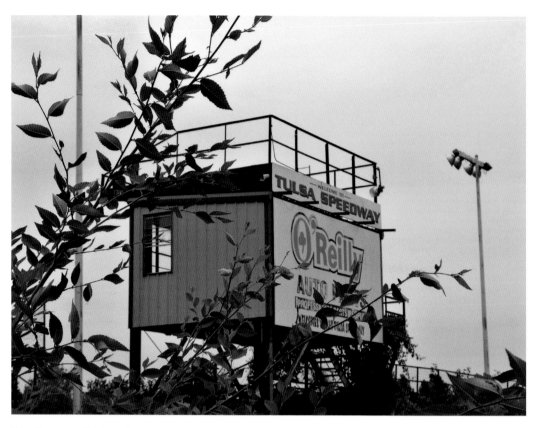

Tulsa Speedway. [*Johnny Fletcher*]

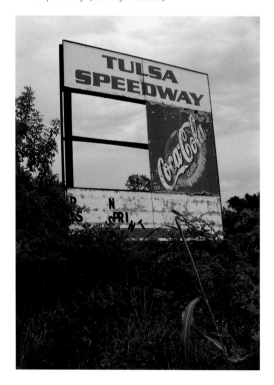

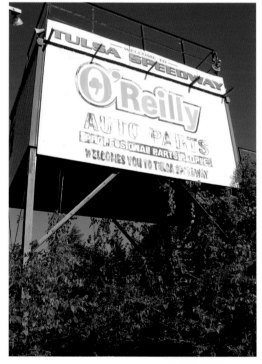

Tulsa Speedway. [*Johnny Fletcher*]

5

LIVING AN ABUNDANT LIFE

Billy Dixon

Buildings are like people in quite a few ways if you really think about it. They come with their own history, energy, and personality. Like people, sometimes you find yourself drawn to a building, without really knowing why. Sometimes they get under your skin. The Abundant Life building is one of those structures. It's got personality and history. Though striking, it doesn't really fit in with the rest of downtown Tulsa, with its skyscrapers and Art Deco influence. It has a draw—and I definitely felt that draw when I moved to Tulsa. Maybe I'm getting ahead of myself, though. Let's get into some of the Abundant Life building's history.

A BRIEF HISTORY OF LIFE

For many Oklahomans, especially Tulsans, Oral Roberts is a household name. He is a pretty eminent and renowned guy. Granville Oral Roberts was born in 1918 in Oklahoma and had a humble, religious upbringing. Roberts' father was a farmer and a preacher, and his mother reportedly committed his life to God's service before he was even born. Roberts, who suffered from a stutter and rejected his family's faith as an adolescent, contracted tuberculosis as a young man. As Oral's health declined from the disease, his family took him to a tent revival in Ada, Oklahoma, hoping to find healing for his affliction after seeing others healed by the reverend at this revival. At this time, Oral reportedly heard God's voice telling him he would be healed, given God's healing power, and would build a university in God's name. Oral was reportedly so weak that he could not stand on his own when being prayed over by the reverend, but was "instantly" healed of his tuberculosis. As an added bonus, his stutter left him at this time, too.

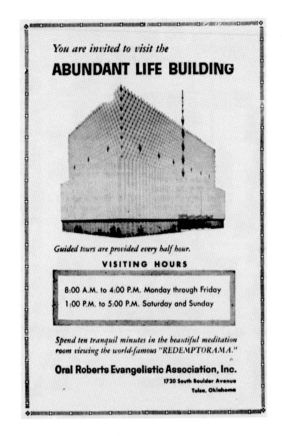

You are invited to visit the

ABUNDANT LIFE BUILDING

Guided tours are provided every half hour.

VISITING HOURS

8:00 A.M. to 4:00 P.M. Monday through Friday

1:00 P.M. to 5:00 P.M. Saturday and Sunday

Spend ten tranquil minutes in the beautiful meditation room viewing the world-famous "REDEMPTORAMA."

Oral Roberts Evangelistic Association, Inc.

1720 South Boulder Avenue
Tulsa, Oklahoma

Right: Open house invitation. [*Tulsa Star*]

Below: Abundant Life at night.
[*Unknown Source*]

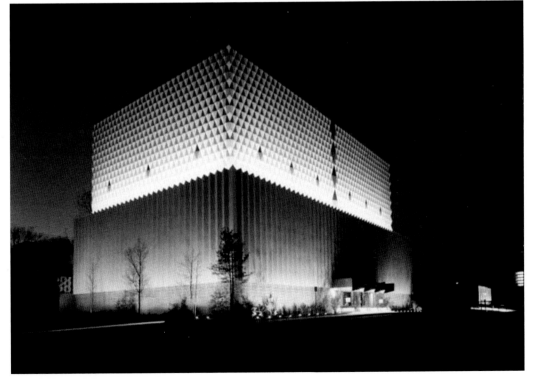

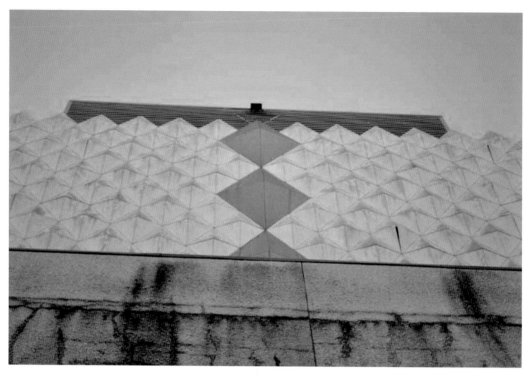

Gold accents on exterior. [*Billy Dixon*]

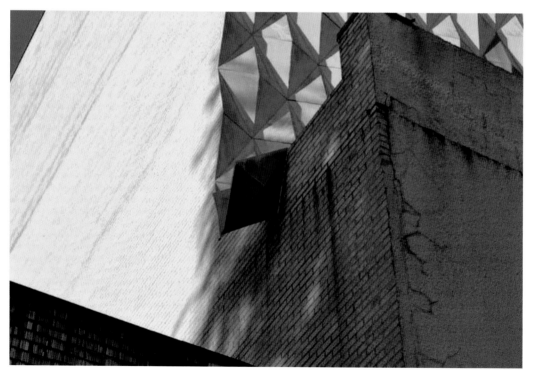

Drain spout on exterior. [*Billy Dixon*]

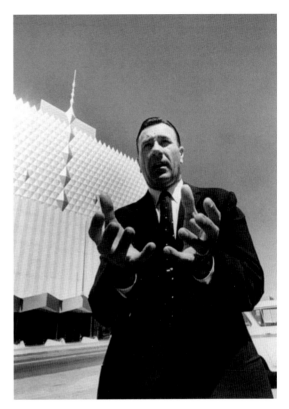

Right: Roberts speaking in front of the Abundant Life building. [*Unknown Source*]

Below: Roberts during construction. [*Unknown Source*]

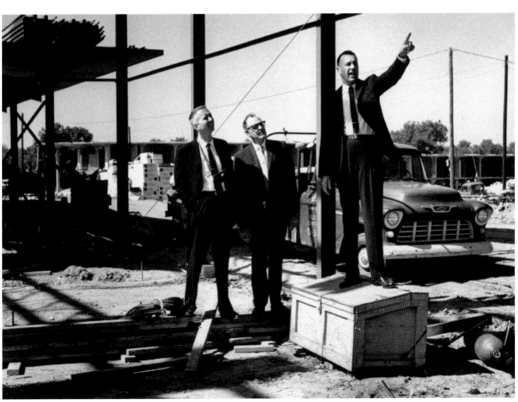

Construction of the Abundant Life building. [*Unknown Source*]

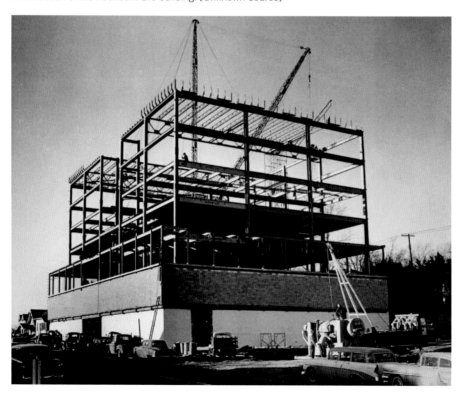

Following his recovery from tuberculosis, Oral began the career that would make him famous. During this time, he met and married his wife, Evelyn, who had a similar Pentecostal background, with whom he would have four children. After working as a part-time pastor in Oklahoma, with some success, Oral began exploring other routes to complete his life's work of ministry. Oral began leading tent revivals, which quickly grew in popularity. Oral reportedly took part in several notable healings, which boosted his notoriety in the community. In 1948, Oral founded the Oral Roberts Evangelistic Association. As Oral's ministry grew, he received significant opposition for facilitating interracial meetings. Sometimes this opposition actually led to attempts at violence. Furthermore, Oral was considered controversial as a minister because of his practice as a "prosperity preaching and healing" minister. In one anecdote about his father, Richard Roberts described how a woman stood while his father preached, exclaiming that her baby had died. Richard described how his father stopped mid-sermon to "lay hands on that child. And that child came back to life again". As his career continued, Oral created the Abundant Life Prayer Group (1958) and founded Oral Roberts University (1965), as well as raising his family. Oral and his wife became members of the Boston Avenue Methodist Church in Tulsa in 1968, reportedly to mitigate what he saw as a hindrance to his popularity—the strict doctrine of Pentecostal teachings.

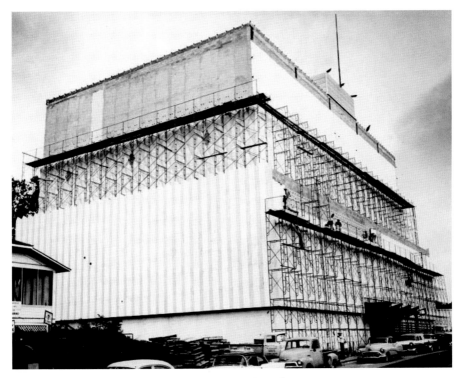

Construction of the Abundant Life building. [*Unknown Source*]

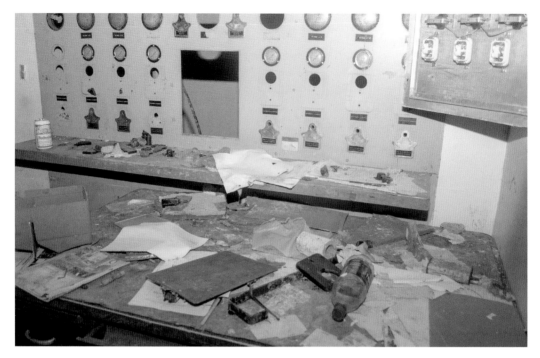

Interior of electrical room. [*Billy Dixon*]

Empty key holders scattered in an office room. [*Billy Dixon*]

What Oral Roberts is probably the most famous for, however, is becoming a pioneer of televangelism. In 1955, Oral changed the landscape of evangelism by bringing cameras into the mix and announced his goal to win one million souls for Christ in 1956. His audience was considerable—Roberts reached millions with his televangelism. Followers from around the globe were able to tune in to hear Roberts speak the word of God, worship together from the comfort of home, and witness Roberts' healings. Roberts' career in ministry continued and the university thrived—with schools of dentistry and law opening in 1978 and 1978. Later in Oral's life, funding for the university declined, leading to issues with debt, and a new president took over the school. When this happened, Oral remained chancellor of the university. Oral passed away in 2009 from a battle with pneumonia in Newport Beach, California.

I know that was a long-winded history of the man behind the building, but he's not really why we're here, is he? Let's get into the focal point of why you are reading this—the Abundant Life building. Roberts purchased a property at 1648 S. Boulder for a headquarters in 1948. However, as his popularity and success rose, Roberts began plans for a bigger headquarters with space for his grand plans and operations. Roberts broke ground on the Abundant Life building, located a short way from his original headquarters at 1720 S. Boulder, on May 23, 1957. The building was designed and constructed during the mid-century modern era of design, which is reflected in the repeated diamonds and gold accents in the design of the facade. The two-inch thick granite used on the facade was personally selected from a quarry in Vermont by Roberts. The architect of the building was Cecil Stanfield, another Oklahoma native, who designed and built multiple structures in our state. Roberts collaborated with Stanfield to incorporate features that he found to be appropriate; namely, the building's unique lack of any windows or natural light. With the emergence of modern technologies, such as central air conditioning and fluorescent lighting, Roberts felt that windows were unnecessary. The interior design, instead, included brightly painted walls. The building itself is 108,000 square feet, seven stories high, and, at the time of its use, included a banquet hall, television studio, and facilities to process the huge amounts of mail donations Roberts received. Roberts had the television studio designed to be reminiscent of the tents where he held the revivals that built his career and popularity. The realization of the Abundant Life building being complete was a tremendous success for Roberts.

Though designed specifically for this purpose, Roberts moved his headquarters to the university in the mid-sixties. The Abundant Life building was utilized less and less and was completely abandoned by Roberts by the mid-seventies. The telephone company, Southwestern Bell, utilized the building briefly, but it has not been utilized since the 1980s. For decades the building has stood boarded up and closed.

Hallway leading from the lobby to the main office rooms. [*Billy Dixon*]

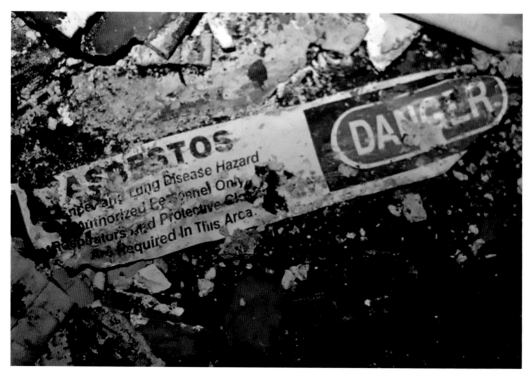

Asbestos warning tape that litters the floor. [*Billy Dixon*]

Empty office room. [*Billy Dixon*]

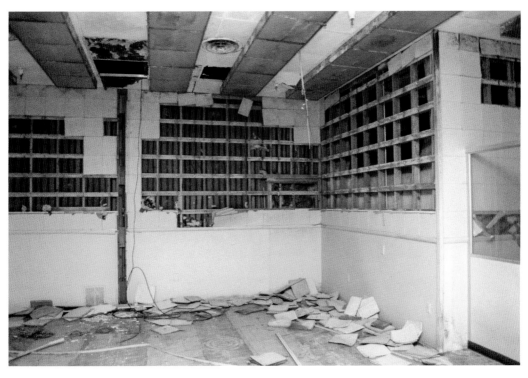

What is left of a section of the mail office room. [*Billy Dixon*]

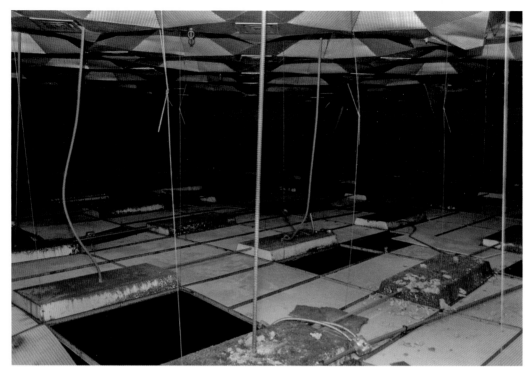

Drop ceiling that was installed after Roberts moved his studio. [*Billy Dixon*]

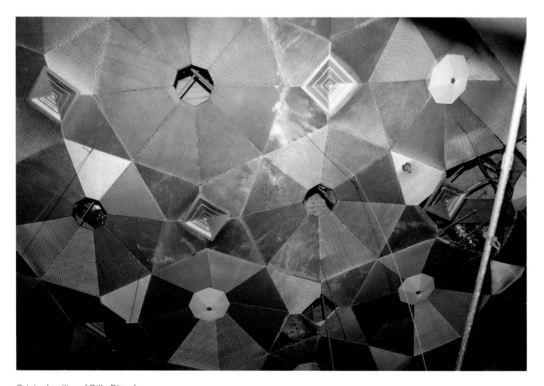

Original ceiling. [*Billy Dixon*]

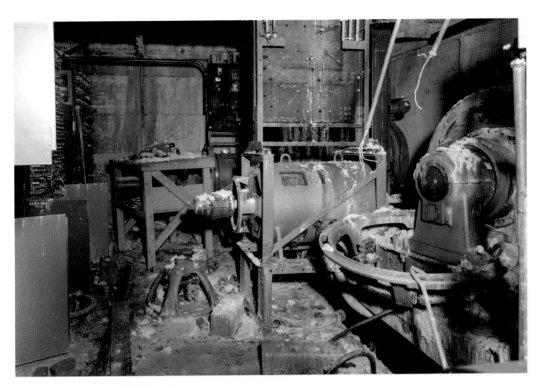

Elevator room. [*Billy Dixon*]

The building had received some city violations in the 2000s and saw a rise in notoriety briefly in 2013 when a transient man, who broke into the building seeking refuge from winter weather, fell down an elevator shaft and died. Preservation Oklahoma, a non-profit working to restore and protect historical landmarks, added the Abundant Life building as one of the most endangered historic places in 2016. In late 2019, workers began moving the iconic diamond granite from the facade of the building to ensure safety after pieces began falling. As of today, the building sits, mostly facade-less, and enclosed in high fencing. And, there you have it—a brief history of the Abundant Life building. As of now, unfortunately, the future for the building is uncertain.

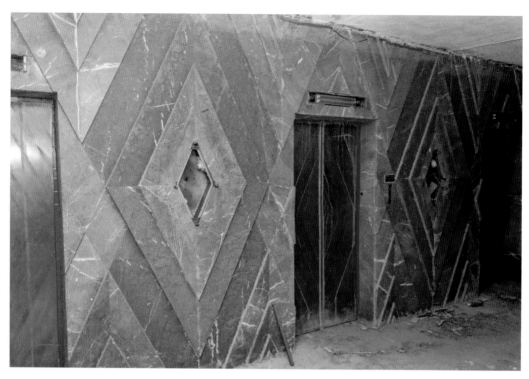

Front lobby and elevator entrances. [*Billy Dixon*]

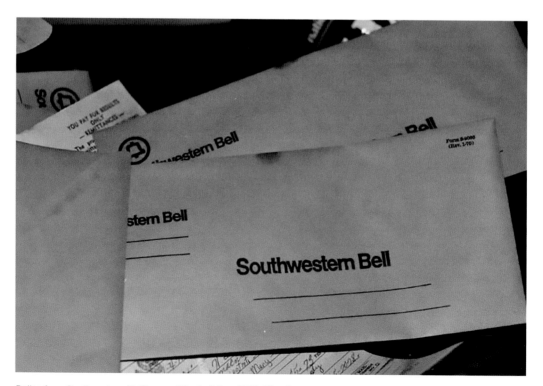

Relics from Southwestern Bell's use of the building. [*Billy Dixon*]

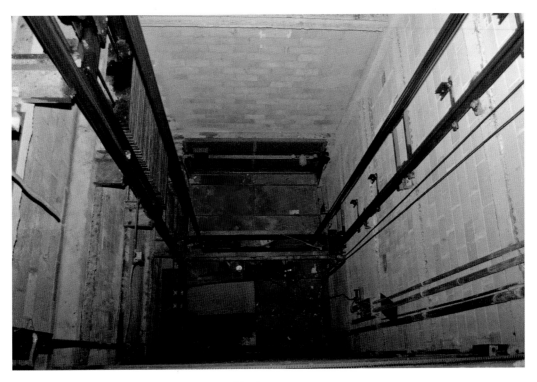

Third floor look at the elevator shaft. [*Billy Dixon*]

Maintenance area. [*Billy Dixon*]

So Where Do I Come In?

I started developing my love for urban exploring a number of years ago, in early summer 2005. So, obviously, when I moved to Tulsa in 2012, I had already been a member of Abandoned Oklahoma and of the urban exploration scene for quite a while. I was born and raised in the Oklahoma City area, so OKC was primarily my stomping grounds when I went exploring. When I found out I would be moving to the Tulsa area, I was excited to see some of the most notorious abandoned places in Northern Oklahoma, like Hissom Memorial, the Tulsa Club building, and the Abundant Life building, with my own eyes. I have always been fascinated by abandoned architecture, but there was just something about the Abundant Life building that especially caught my interest—and stuck.

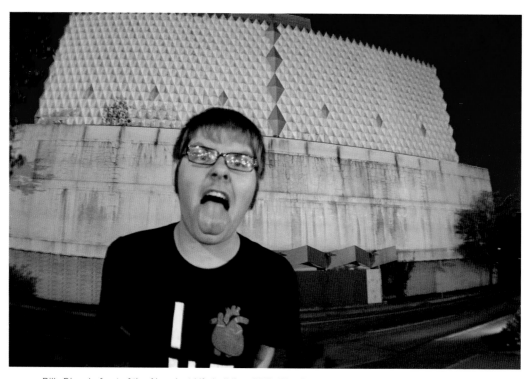

Billy Dixon in front of the Abundant Life building. [*Billy Dixon*]

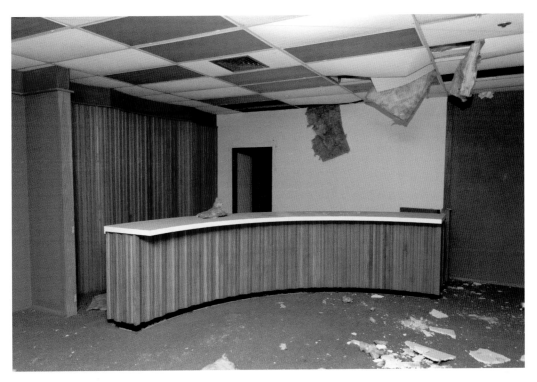

One of the main desks in the office area. [*Billy Dixon*]

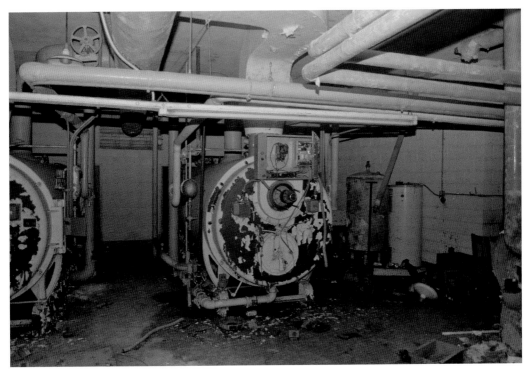

Basement room. [*Billy Dixon*]

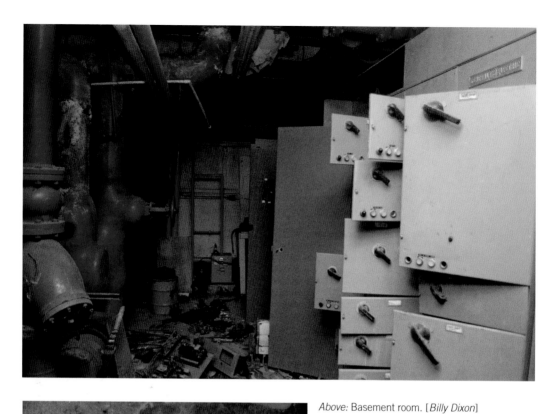

Above: Basement room. [*Billy Dixon*]

Left: Tulsa Club original glass panel
[*Billy Dixon*]

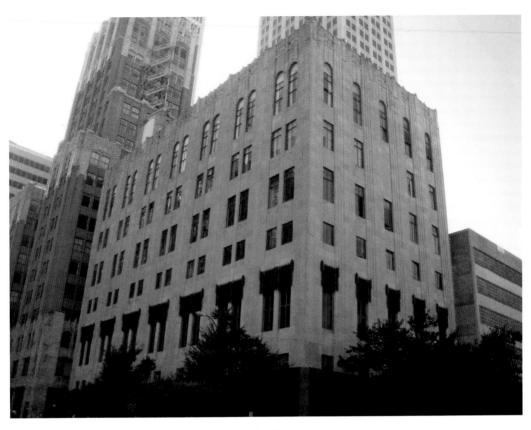

Exterior of Tulsa Club before renovations. [*Billy Dixon*]

Water damage within the Abundant Life building. [*Billy Dixon*]

Excessive heat and water damage to walls. [*Billy Dixon*]

Since being abandoned, the Abundant Life building has been surrounded by rumors and mystery—perhaps because of the controversy surrounding Roberts himself or maybe because of the peculiarity of the structure itself. Regardless of how these rumors and mystery began, for me at least, they just added to the allure of the building. Something else that piqued my interest in the building is the challenges that the design of the building itself presents for urban explorers. The lack of windows makes it like a Fort Knox of abandoned architecture—seemingly impenetrable. Entries to the building are limited to mainly two back doors, a roof access door, and a freight elevator door; these are also the only outside sources of light in the place. Rather than being discouraged when presented with this information, I instead thought to myself, challenge accepted.

Rear dock entrance. [*Billy Dixon*]

View of downtown Tulsa from the rooftop of the Abundant Life building. [*Billy Dixon*]

View of downtown and the elevator motor room. [*Billy Dixon*]

Billy Dixon in the sixth-floor lobby where Roberts held his sermons. [*Billy Dixon*]

ABOUT THE AUTHORS

MICHAEL SCHWARZ

Starting from a young age, Michael Schwarz always loved exploring. He can remember venturing off and scoping out the houses being built in the developing neighborhood right behind his house. As he got older, he found himself appreciating the work and love that went into architecture and just being excited to pass by the beautifully designed places in his downtown. That's why when he found out there were historic properties all over Oklahoma that were just sitting abandoned, he couldn't help but want to do something about it. In high school, he discovered the website AbandonedOK.com and started exploring and taking pictures to contribute to their large online database. Upon graduating, Schwarz moved to Arkansas to attend college and started his own version, AbandonedAR.com. It wasn't until he came across the Majestic Hotel in Hot Springs, AR, that Schwarz started to fight for the preservation of buildings. Unfortunately, the Majestic was lost to demolition and in honor of what could have been, he is now committed to continuing that fight to try and save these forgotten places before it is too late. "If we can't physically save them, I hope that their history and the memories created within their walls can live forever on the internet."

EMILY COWAN

Emily spends most of her free time researching and exploring these magnificent pieces of Oklahoma and Kansas history. She enjoys getting together groups of friends to go out and adventure not only abandoned places but all that Oklahoma has to offer. Abandoned Oklahoma has provided Emily many new opportunities to improve her writing, coding, web design, communication, and leadership skills. On top of that, she now has the opportunity to become a published author and work "hands on" to restore history. "I have gotten to meet great people along the way and plan to make many more friends in Kansas now that I have gotten the Abandoned Kansas website up and running."

Emily Cowan

Jennifer Burton

JENNIFER BURTON

Jennifer Burton resides in Oklahoma and has been passionate about the history of abandoned buildings from an early age. She has photographed countless abandoned buildings and sees the beauty in what once was. She is very proud of the work that Abandoned Oklahoma has done and is looking forward to telling the stories of many more abandoned locations in the future.

JOHNNY FLETCHER

Born and raised in Bartlesville, Oklahoma, Johnny is the oldest of the Abandoned Oklahoma Team. He has lived on the same street his whole life and began his urban exploring hobby (officially) in 2008. In his teen years, not knowing of such a thing as "urban exploring," he started checking out abandoned houses around his neighborhood. "There was a fantastic empty two-story house just down the road from my neighborhood. A local organization had turned it into a haunted attraction. We started checking it out after they were done with it and had left it abandoned. We would just run around there with flashlights and have a great time. In later years, a friend had mentioned a website that featured abandoned locations in Arkansas. I looked at some photos of 'Dogpatch USA,' an abandoned theme park. I was hooked, I just had to go see that place one day." He started talking to people on the internet from exploring websites, and they met up and became fast friends. When the Abandoned Oklahoma website first began, he was asked to become a part of the team. "I have been on so many adventures and I've seen so many amazing buildings and structures since I started doing this. We are truly capturing history with our cameras. Some of those buildings are now demolished and gone forever." Johnny feels that his team has preserved history through their photos. Johnny continues to contribute to the Abandoned Oklahoma website in his spare time.

BILLY DIXON

As kids, most of us rode our bikes or walked by that old creepy house in the neighborhood and dared one of our friends to enter it. Billy Dixon drew that short straw one summer afternoon and it lit a flame that has never burned out. Originating from Oklahoma, the passion Billy shared with the Abandoned Oklahoma team has become a chapter of his life that never fails to continue. He spent his late teens and nearly all of his precious twenties traveling all around Oklahoma, spending innumerable hours to explore, research, and scavenge through the walls of some of Oklahoma's forgotten and undervalued structures. From the larger locations such as Hissom Memorial, Camp Scott, and the Tulsa Club Building to the some of the smaller locations like Hotel Marion, Sleepy Hollow, and Jewel Theatre, each hold a special place to Billy. "That small note left, writing on the wall, or relic that has been discarded as trash means something to me."

BIBLIOGRAPHY

THE PRIDE OF OUR BEGINNINGS

Bratcher, Michael. "Board Member Urges Cutting Ties to School." *The Daily Oklahoman*, 26 Sept. 2003.

Decker, Stefanie Lee. "Luper, Clara Shepard: The Encyclopedia of Oklahoma History and Culture." *Luper, Clara Shepard*, The Encyclopedia of Oklahoma History and Culture, 1997, www.okhistory.org/publications/enc/entry.php?entry=LU005.

Dunjee, Roscoe. "The Black Dispatch (Oklahoma City, Okla.), Vol. 7, No. 48, Ed. 1 Thursday, November 2, 1922." *The Gateway to Oklahoma History*, Oklahoma Historical Society, 20 Mar. 2013, gateway.okhistory.org/ark:/67531/metadc152409/.

Laskey, Eleanor. "Dunjee Interview." 13 Sept. 2016.

Loudenback, Doug. "The African American Press." *The Black Dispatch*, 2004, www.dougloudenback.com/maps/vintage_blackdispatch.htm.

McCullough, Carmeletta Payne. "Dunjee Interview." 13 Sept. 2016.

Mitchell, Sterling. "Dunjee Interview." 13 Sept. 2016.

Money, Jack, and Steve Lackmeyer. "Dunjee School Project Leading National Trend." *The Daily Oklahoman*, 7 Dec. 1997.

Thompson, John H. L. "Dunjee, Roscoe: The Encyclopedia of Oklahoma History and Culture." *Dunjee, Roscoe | The Encyclopedia of Oklahoma History and Culture*, The Encyclopedia of Oklahoma History and Culture, 1990, www.okhistory.org/publications/enc/entry.php?entry=DU007.

LINDLEY HOSPITAL

"[BASEMENT BOX 67.0286]." *The Gateway to Oklahoma History*, 23 Dec. 1957, gateway.okhistory.org/ark:/67531/metadc204544/.

Duncan Convention & Visitor's Bureau, www.visitduncan.org/.

"Duncan | The Encyclopedia of Oklahoma History and Culture." *Oklahoma Historical Society*, www.okhistory.org/publications/enc/entry.php?entry=DU005.

Newspapers.com, www.newspapers.com/.

"Our History." *Duncan Regional Hospital*, duncanregional.org/our-history.

TULSA SPEEDWAY

Tucker, Mike. "Tulsa Speedway Comment Section." *Abandoned Oklahoma*, The Abandoned Atlas Foundation, 24 Mar. 2010, abandonedok.com/tulsa-speedway/.

Sharp, Scott. "Edwards Says No to Tulsa." *The Daily Oklahoman*, 6 Oct. 2006, p. 5C.

Turnham, Amanda. "Tulsa Speedway." *ForgottenTracks*, 20 Feb. 2010, http://www.forgottentracks.com/tulsaspeedwayok.htm.

LIVING AN ABUNDANT LIFE

Harrell, David Edwin. *Oral Roberts: an American Life*. Indiana University Press, 1985.

Jones, Corey. "Diamond Facade of Abundant Life Building Being Removed as Safety Precaution after Some Have Fallen." *Tulsa World*, 23 Dec. 2019.

Relate, Bp. "Biography of Oral Roberts." *Believers Portal*, 6 Mar. 2019, believers-portal.com/biography-oral-roberts/.

Wofford, Jerry. "Homeless Man Killed in Fall in Vacant Abundant Life Building." *Tulsa World*, 21 Dec. 2012.